FOOTBALL

BRITAIN IN PICTURES

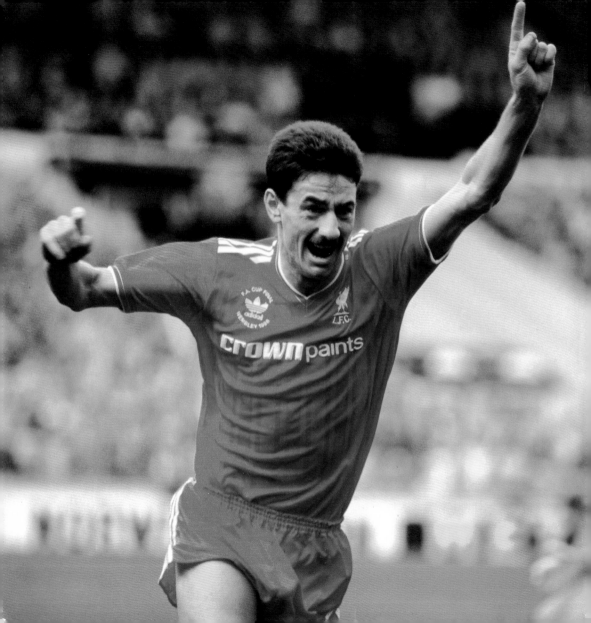

FOOTBALL

BRITAIN IN PICTURES

AMMONITE
PRESS

**PRESS
ASSOCIATION**
Images

First published 2012 by
Ammonite Press
an imprint of AE Publications Ltd,
166 High Street, Lewes, East Sussex, BN7 1XU

This title has been created using material first published in
100 Years of Football (2008)

ISBN 978-1-90770-844-2

British Cataloguing in Publication Data. A catalogue
record of this book is available from the British Library.

Editor: Neil Kelly
Managing Editor: Richard Wiles
Picture research: Press Association Images
Designer: Jo Patterson

Colour reproduction by GMC Reprographics
Printed and bound in China by C&C Offset Printing Co Ltd

Contents

Chapter One

PEOPLE

THE GREAT AND GOOD

For all the epic competitions, it is the big personalities who make football such an enthralling game.

Giants of the old English Division One included Steve Bloomer, a striker who notched up an impressive 314 goals in 534 matches. Giant goalkeeper William Foulke weighed 25 stone and was the antithesis of today's ultra-slim players, but no less effective. Billy Meredith left his mining roots behind to play for Manchester City. He scored both goals for City in the first Manchester derby, went on to play for Manchester United and turned out in the FA Cup aged 49.

Right: Bill 'Fatty' Foulke, Chelsea goalkeeper.
11th September, 1905

Far right: Bill 'Dixie' Dean, Everton.
26th September, 1931

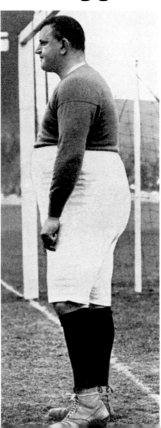

THE 1910s TO THE 1950s

Dixie, or William, Dean became the most prolific scorer in English history. He averaged a goal a game, even more for his country. Ted Drake is remembered as the first man to win the Division One title as both player and manager, but also as a lethal finisher, netting 44 goals in one season for Arsenal as well as seven in one match.

Hughie Gallacher rose through the Scottish ranks and became one of Newcastle United's finest ever players, netting 143 times. Danny Blanchflower was inspirational for both his clubs and Northern Ireland. John Charles starred for Wales, Leeds, Cardiff, Juventus and Roma.

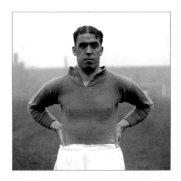

Sir Matt Busby crossed the divides by playing for both Manchester clubs, Liverpool and his country; going on to manage Manchester United to five league titles and the European Cup. Other successful players of the time included Sir Stanley Matthews, Nat Lofthouse and Billy Wright.

SWINGING SIXTIES

The 1960s were the biggest decade yet for English football due in no small part to England's famous World Cup win in 1966.

The whole of the England team and its manager Sir Alf Ramsey are venerated as heroes to this day. In the annals of English football, the likes of goalkeeper Gordon Banks, midfield battler Alan Ball, brothers Sir Jack Charlton and Sir Bobby Charlton and the scorer of a hat-trick in the final, Sir Geoff Hurst are legendary. A year later Glasgow Celtic became the first UK club to win the European Cup by beating Inter Milan 2–1 in the final with Tommy Gemmell netting a spectacular winner. Glasgow

Rangers responded by winning the Cup Winners' Cup in 1972 led by captain John Greig. Denis Law played for Manchester City, before helping Manchester United to win the European Cup in 1968.

Bill Shankly spent 15 years at the helm of Liverpool bringing them a trio of First Division titles, two FA Cups and the UEFA Cup.

Jimmy Greaves was devastated to miss most of England's 1966 World Cup triumph, but his glittering career saw him hit the net 357 times in 516 First Division games with 44 goals in his 57 internationals. George Best, one of the wildest spirits the game has ever seen, was also one of its most supreme talents, playing for Manchester United, Northern Ireland, Hibernian and Fulham. Best was one of the first real superstars of UK football.

SEVENTIES STARS

The 1970s saw English football really take off as Liverpool snared the European Cup in 1977 and 1978, followed in 1979 by Brian Clough's Nottingham Forest. Clough was arguably the greatest manager of the decade, bringing a no-nonsense attitude to management.

The decade also saw two legends emerge at the other end of the pitch – in Pat Jennings and Peter Shilton. Jennings was perhaps Northern Ireland's greatest ever goalkeeper as well as being eulogised by the fans of both London rivals Arsenal and Tottenham Hotspur. Shilton meanwhile starred for England and a host of English club sides, winning two European Cups with Nottingham

Peter Shilton, Leicester City goalkeeper.
23rd March, 1968

9

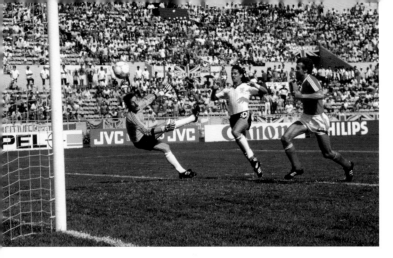

England's Gary Lineker (C) scores the second of three goals against Poland.
11th June, 1986

well as the skilful management of Sir Bobby Robson for club and country. Two Welshmen also hit the headlines in the form of prolific striker Ian Rush at Liverpool and goalkeeper Neville Southall at Everton.

THE NINETIES

The 1990s saw the Sky TV revolution, the revamped European Cup (the Champions League) and the new Division One (the Premier League, better known as the 'The Premiership'), which brought glamour and money into the English game as never before. With the new riches came a host of talents from overseas.

Manchester United led the way with nine Premier League titles under the stewardship of Sir Alex Ferguson. He brought in foreign players such as the sublimely talented Frenchman Eric Cantona and goalkeeper Peter Schmeichel, though British talents such as David

Forest and then becoming the first player to make 1,000 professional appearances in England. Bob Paisley filled the shoes of Shankly at Liverpool by taking the club to three European Cups and six First Division championships. Essential to his success were his brace of Scots, Alan Hansen and Kenny Dalglish. Another key striker was Englishman Kevin Keegan, who played for Liverpool before moving to Hamburg.

EIGHTIES HEROES

The domination of English clubs in Europe continued in the early 1980s with Clough, Paisley, Dalglish and Hansen prime movers in the European Cups lifted by Nottingham Forest in 1980, Liverpool in 1981 and Aston Villa in 1982. Liverpool won in 1984 before losing to Juventus in the tragic Heysel final in 1985, which led to English clubs being banned from Europe for five years.

Graeme Souness headed north in 1986 to manage Rangers, sparking a revolution that brought England team stalwarts Terry Butcher, Chris Woods and Gary Stevens to Glasgow.

The 1980s saw the rise of one of England's greatest ever strikers, Gary Lineker, and one of its finest ever captains, Bryan Robson, as

Beckham and Ryan Giggs also excelled as Manchester United won the Champions League in 1999.

NEW MILLENNIUM

This is a decade of footballing superstars like never before with Beckham-mania reaching new heights, with other key media figures including Thierry Henry at Arsenal, Wayne Rooney at Manchester United and John Terry at Chelsea. The influx of foreign players and managers, including the highly successful Arsene Wenger at Arsenal continues.

Some commentators suggest that this focus on individual players is having a negative impact on the national side as England joined the other Home Nations in failing to qualify for Euro 2008.

Celtic and Rangers meanwhile both qualified for the first time for the latter stages of the Champions League and shortly after the national team recorded back-to-back wins over France with Everton's James McFadden scoring the winner in Paris. Proof, perhaps, that the commentators are right, and that including more homegrown players in the domestic competitions goes hand in hand with international success.

Arsene Wenger, Arsenal manager, at a 3–1 home victory against Fulham.
29th April, 2007

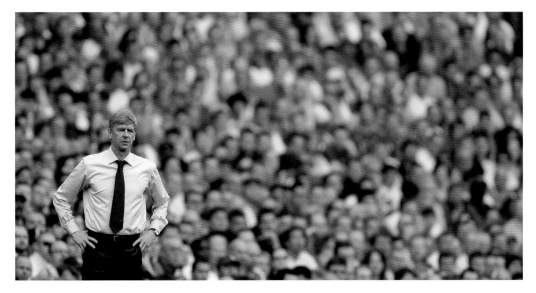

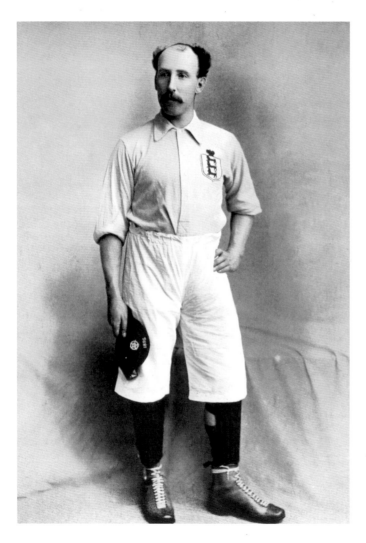

John Reynolds, Aston Villa. Reynolds won eight caps for England, in whose shirt he is shown, and five for Ireland. He played for Villa from 1893 to 1897, making 96 League appearances for the club.
1895

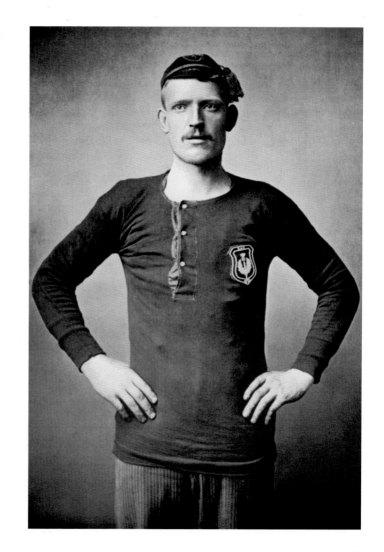

David Russell, Heart of Midlothian and Scotland. Capped six times for his country, he was also the first Hearts' player to score a League hat-trick in a game against Renton.
1895

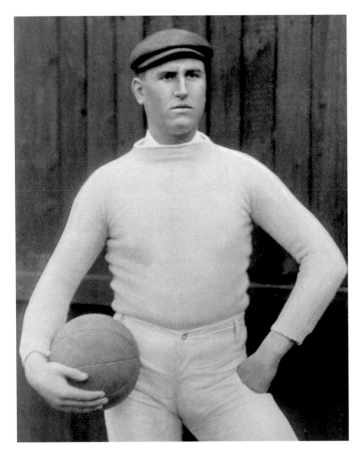

Jack Hillman, shown here during his time as a goalkeeper for Everton. Known as 'Happy Jack' throughout his career, he made his name at Burnley, making 100 appearances for the club between 1890 and 1895. After his stint at Everton (1895–97), he went on to provide a safe pair of hands for Dundee, Manchester City and Millwall. **1895**

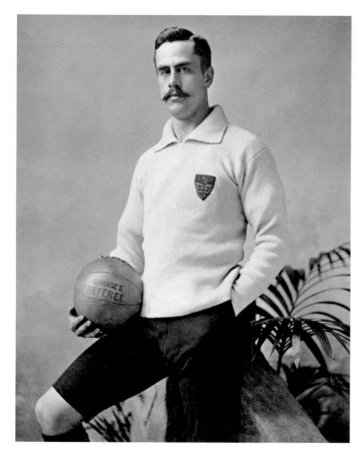

William 'Billy' Moon, Old Westminsters and England goalkeeper. Moon made his first appearance for his country in a victory over Wales in 1888. He was capped seven times in total, taking the captaincy in 1891 when England played against Scotland. Educated at Westminster school, he was a solicitor by profession. Moon also kept goal for Old Westminsters FC, and guested for Corinthians FC between 1886 and 1901. A talented cricketer, he played as a wicket-keeper for Middlesex CCC during the 1891 County Championship. **1895**

Steve Smith, England international and Aston Villa winger. A well-respected outside-left, Smith played for Aston Villa from 1893 to 1901, forging an important role in the club's consecutive victories in the League title from 1894 to 1900, and the FA Cup in 1895. He made one international appearance for England against Scotland in 1895.
1895

Facing page: Caesar Jenkyns, Woolwich Arsenal captain. A Welsh-born centre-half, Jenkyns played for several English clubs, as well as winning eight caps for Wales. He became the Arsenal captain in 1895, entering the history books as the club's first international player. A star player at Arsenal, he left in the summer of 1896, moving on to Newton Heath – the club that would later become Manchester United. He spend two seasons at Newton Heath, helping the club achieve the runners-up place in the Second Division in 1897.
1895

England captain Gilbert Oswald 'G.O.' Smith was regarded by many as the first great centre-forward. Educated at Charterhouse School – where he learned many of his footballing skills – and Keble College, Oxford, he was a teacher by profession. With 20 caps and 11 international goals, Smith was renowned for his balance, timing and ball control. By the time he retired in the early 1900s, Smith had become one of the most admired figures in the English game.
1900

Steve Bloomer, a quick-thinking goal-scorer who was equally adept with either foot. He played for Derby County, Middlesbrough and England during the 1890s and 1900s. Bloomer's speciality was the daisy cutter – a low, fast, powerful and accurate shot. In 536 appearances in English First Division games, he scored 317 goals. After Jimmy Greaves, this makes him the second highest all-time goal-scorer in the First Division. Bloomer also scored 28 goals in 23 appearances for England.
1904

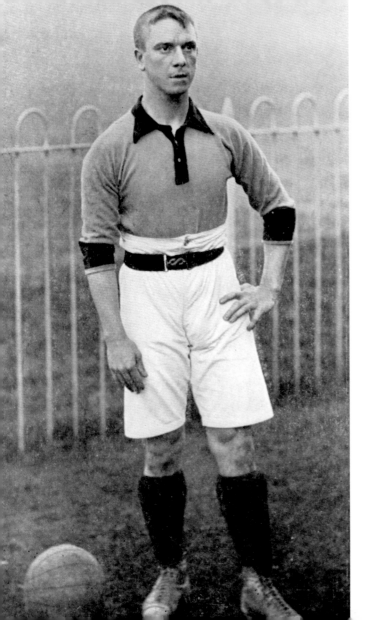

Dan Cunliffe, pictured here during his time at Portsmouth (1901–1906). He scored Portsmouth's first goal in the FA Cup, during a 1–1 draw with Blackburn Rovers on 1st February, 1900. In a varied career, Cunliffe played as an inside-forward for several clubs, including Liverpool, New Brompton, Millwall Athletic and Rochdale. He made one international appearance at an England v Ireland game in 1900. **1905**

Sam Hardy, shown between the posts at Aston Villa (1912–1921). Recognised as one of the best goalkeepers of his generation, he also played for Chesterfield, Liverpool and Nottingham Forest. At Liverpool (1905–1912) he made 239 appearances, earning himself the well-deserved nickname of 'Safe and Steady Sam'. In 1907 he debuted for England in a 1–0 victory over Ireland, going on to win 21 caps during his career.
26th October, 1912

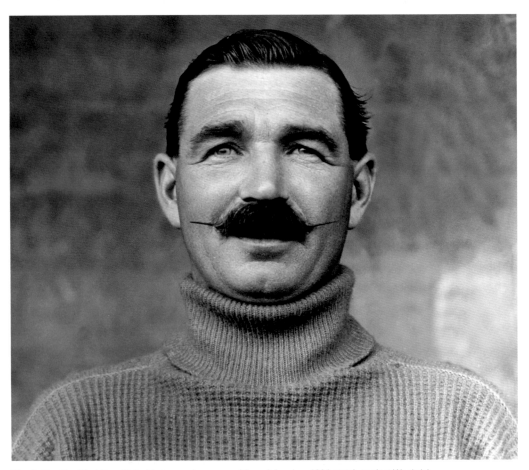

Charlie Paynter, West Ham United trainer and manager. A knee injury in a 1901 match against Woolwich Arsenal ended Paynter's career as a West Ham player. He became a trainer, initially for the reserves and later for the first team. In 1933, he replaced Syd King as manager, holding the position untill 1950.
1919

Arsenal's new signing Fred Pagnam watches a Reserves game between Arsenal and Fulham at Highbury. A star striker for Liverpool, Pagnam made his Arsenal debut against Bradford City on 25th October, 1919. By the end of the 1920–21 season, he had become Arsenal's top scorer with 15 goals. He later played for Watford, becoming the Hornets' top scorer during 1922–23, and the club's manager between 1926 and 1929.

20th October, 1919

West Ham United captain George Kay (L) and Bolton Wanderers captain Joe Smith (R) at Wembley Stadium for the FA Cup in 1923. The match was the first to be played at the original stadium. Huge crowds of around 300,000 people gained entry, exceeding the official capacity of 125,000. Mounted police had to clear spectators from the playing area before the game could begin. King George V was in attendance to present the trophy to Bolton, who claimed a 2–0 victory.
28th April, 1923

Walter Alsford of Tottenham Hotspur (R) being congratulated by teammate Willie Hall (L) after winning his first England cap against Scotland, as the trainer (with hat) and Foster Headley (second R), the Tottenham Hotspur centre-forward, look on.
3rd April, 1925

Charlie Buchan, Arsenal centre forward (L), at Highbury. Signing with Arsenal from Sunderland in 1925, Buchan was a major goal-scorer for the team. He contributed several tactical ideas that exploited the relaxation of the offside law. On 23rd April, 1923 he captained Arsenal at their first-ever FA Cup Final, but Cardiff City beat the Gunners 1–0.
21st April, 1927

Facing page: Arthur Grimsdell, Spurs star and Clapton Orient player-manager. During a successful career with Tottenham Hotspur in the 1920s, Grimsdell made 418 League appearances, scoring 46 goals. He also captained the club when they won the FA Cup in 1921. He became a player-manager at Clapton Orient in 1929.
16th August, 1929

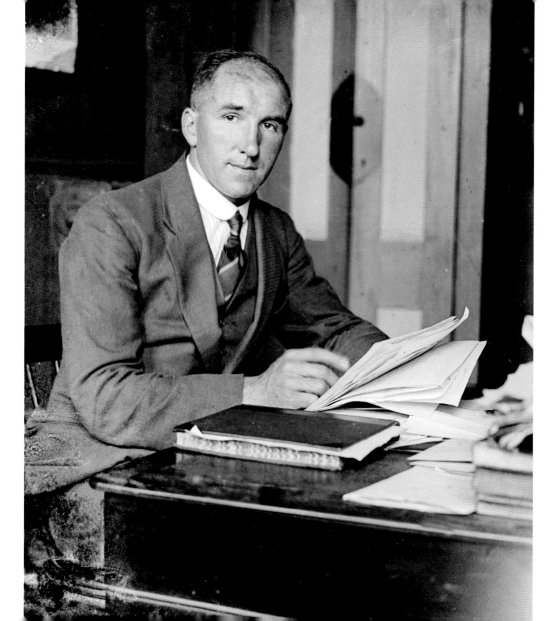

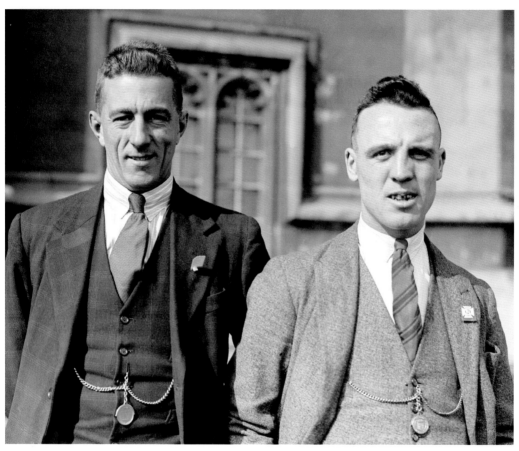

Alf Steward (L) and Bill Dale (R), Manchester United. Steward was a regular goalkeeper at United from 1923 to 1932, leaving the club to become a player-manager at Manchester North End. Bill Dale played as a full-back for United, making his debut in 1928. He made 64 appearances for the club from 1928 to 1931, going on to play for Manchester City, Ipswich Town and Norwich City.

28th September, 1929

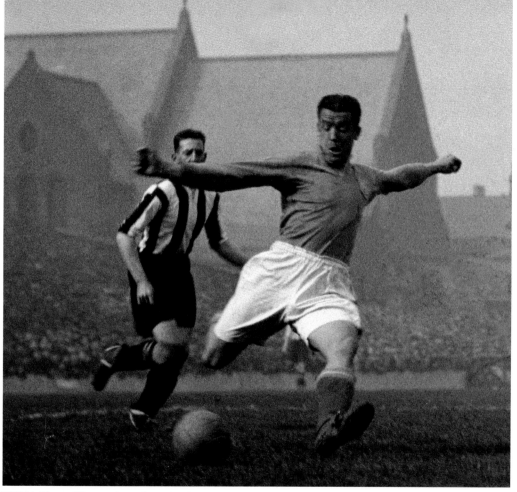

Bill 'Dixie' Dean of Everton shoots for goal at Goodison Park. A centre-forward, Dean started his career at Tranmere Rovers, moving on to Everton in 1925. In the 1927–28 season, Dean scored 60 League goals in one season – he is still the only player in English football to achieve this. He stayed at Everton until 1937, later playing for Notts County and Ireland's Sligo Rovers.

20th October, 1930

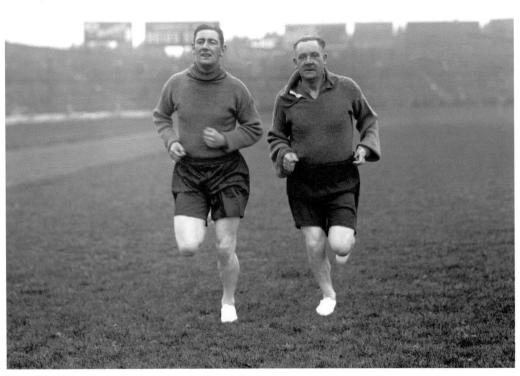

Chelsea's Alec Jackson (L) and Andy Wilson training. Jackson joined the club in 1930 after a period as a successful winger for Huddersfield Town. In his two years at Chelsea, he scored 31 League goals in 78 games. Wilson was a forward and Scottish international – he played for Chelsea from 1923 to 1931, making 253 League appearances and scoring 52 goals.
4th August, 1931

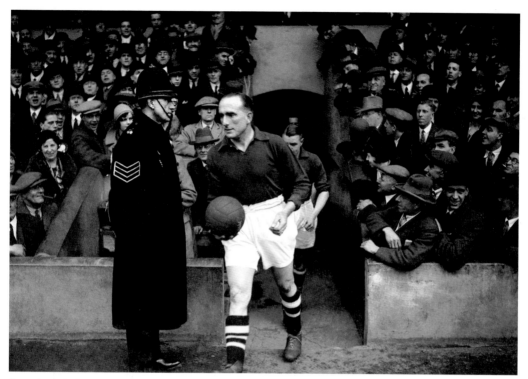

Arsenal captain Tom Parker leads his team out before a match against Newcastle. A former Southampton player, Parker made his Arsenal debut on 3rd April, 1926. This was the first of 172 consecutive first-team matches, an Arsenal record that still stands today. As captain, Parker led the club in their first FA Cup Final (1926–27), which they lost 1–0 to Cardiff City. The 1929–30 season saw a better result – Arsenal beat Huddersfield Town 2–0 and Parker became the first Arsenal captain to lift the FA Cup trophy.

20th February, 1932

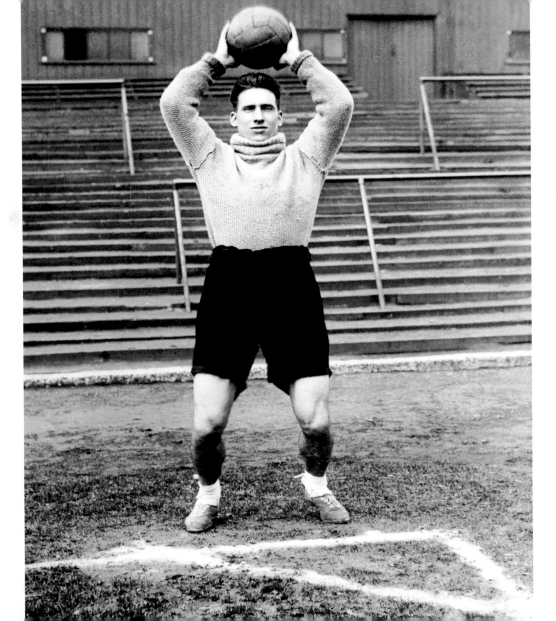

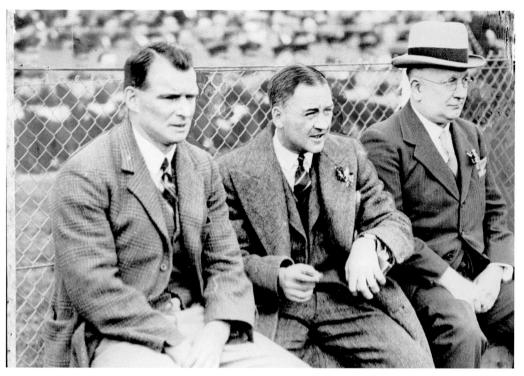

L–R: Arsenal trainer Tom Whittaker, star player Alex James and manager Herbert Chapman watch a match from the sidelines. James played at Arsenal from 1929 to 1937, scoring 26 goals in 231 League appearances. An inside-forward, he is regarded as one of the club's greatest players of all time. A supporting player for strikers, he was renowned for the quality of his passing and unsurpassed ball control.
13th September, 1932

Facing page: Sammy Weaver, Newcastle United. After joining Newcastle United from Hull City in November 1929, Weaver made a big impact at St James' Park. He helped the club to win an FA Cup medal in 1932, and was also capped for England, playing three times for the national team in 1932 and 1933.
22nd April, 1932

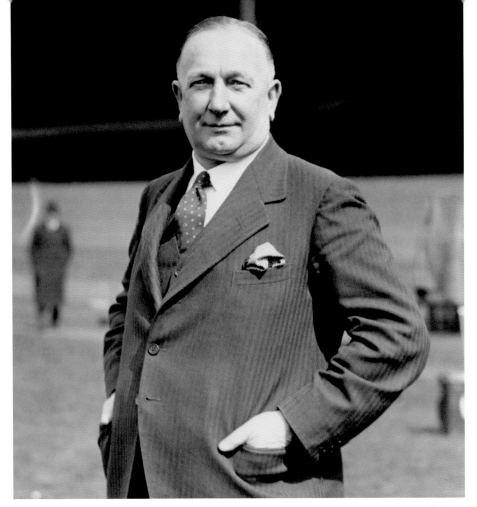

Herbert Chapman, Arsenal manager. Despite an unremarkable playing career, Chapman became one of the most successful managers in early 20th-century English football. He improved the fortunes of both Huddersfield Town (1921–25) and Arsenal (1925–34), and modernised the game, championing flood-lighting and introducing new training and tactics.
1st August, 1932

Tottenham Hotspur goalkeeper Joe Nicholls watches as a Wolves player kicks the ball past him, only to go wide of the goal. Nicholls joined Spurs at White Hart Lane in 1927, playing in 129 matches. In 1936 he moved to Bristol Rovers, featuring in 112 games for the club by 1939.

28th August, 1933

Harry Curtis, Brentford manager from 1926 to 1949. A former referee and manager of Gillingham, he transformed Brentford's fortunes. Under Curtis, the Bees won the Division Three South title in 1932–33 and the Second Division title in 1934–35. In their debut season in the First Division (1935–36), the Bees attained fifth place, making them the highest-placed team from London. Curtis remains Brentford's most successful and longest-serving manager.

1st September, 1934

Wales international William 'Willie' Evans practises his shooting. Capped six times for his country, outside-left Evans also played for Tottenham Hotspur (1931–36). He appeared in 195 League matches and scored 86 goals for the White Hart Lane club.

1st October, 1934

Notts County players training at Meadow Lane in 1935. The club began playing at the stadium in 1910. It was badly damaged during the Second World War and has been rebuilt over the years, but Meadow Lane still remains the home of Notts County FC.
18th August, 1935

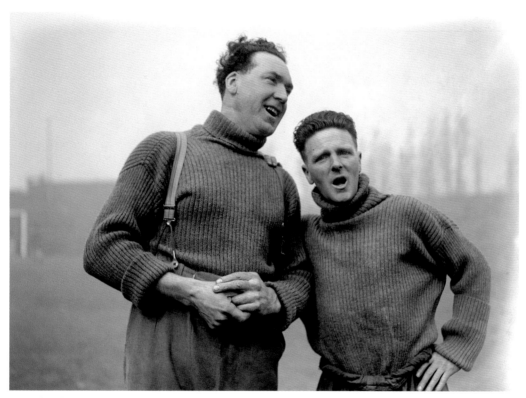

Jackie Crawford, winger for Queens Park Rangers (R) and a colleague discuss tactics. John Forsyth 'Jackie' Crawford joined QPR in 1934 towards the end of his career. He had previously played at Chelsea (1923–34), where he made 308 League appearances and scored 27 goals.

20th March, 1936

Leslie Knighton, Chelsea manager. Knighton took over the post from David Calderhead in 1933, and served as manager until 1939. Previously he had managed Arsenal (1919–25), Bournemouth (1925–28) and Birmingham (1928–33), whom he led to the 1931 FA Cup Final.

30th April, 1937

Walter Winterbottom, Manchester United. Pictured here at a Manchester United training session, he went on to become the first manager of the England football team, guiding the squad from 1947 to 1963.
10th August, 1937

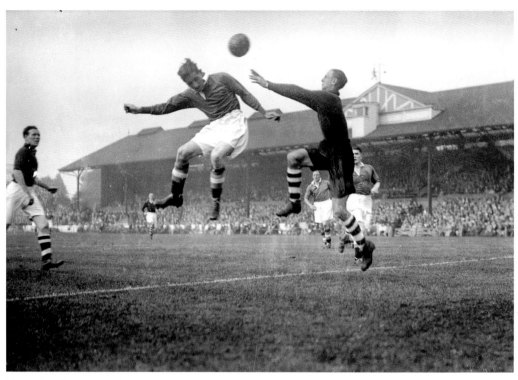

Liverpool goalkeeper Arthur Riley rushes out to challenge Chelsea's George Mills. Riley was a South African, signed by Liverpool's manager Matt McQueen in August, 1925. He spent 15 years at the club, with 338 first team appearances. Mills played for Chelsea from 1929 to 1943. A renowned goal-scorer, he notched up 125 goals in 239 League games.
28th August, 1937

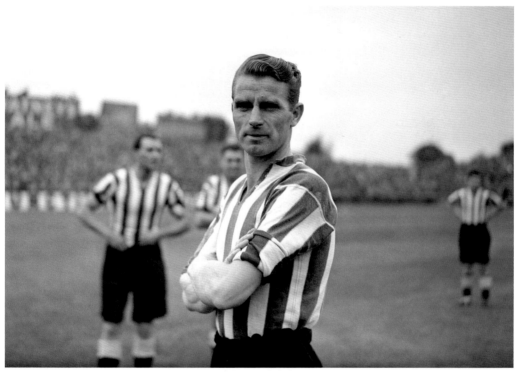

Peter Doherty, guesting for Brentford. A Manchester City player from 1936 to 1945, inside-left Doherty scored 81 goals in 133 League appearances for the club. As well as Brentford, he guested for several other clubs, including Port Vale, Blackburn Rovers, Derby County, Birmingham, Grimsby Town, Lincoln City, Liverpool, Manchester United, West Bromwich Albion and Walsall.

7th September, 1945

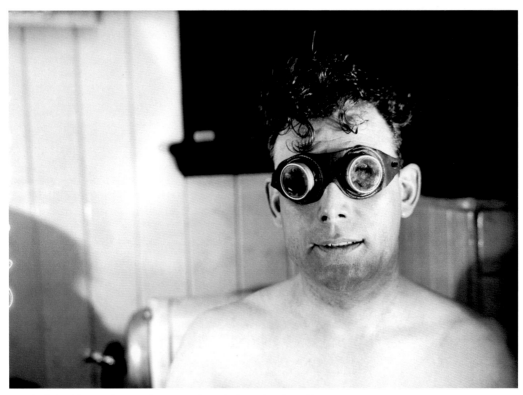

Brentford's Len Townsend protects his eyes with a pair of goggles while taking in the rays from a sun lamp. Townsend was the club's centre-forward and leading goal-scorer during the mid-1940s.
1st March, 1946

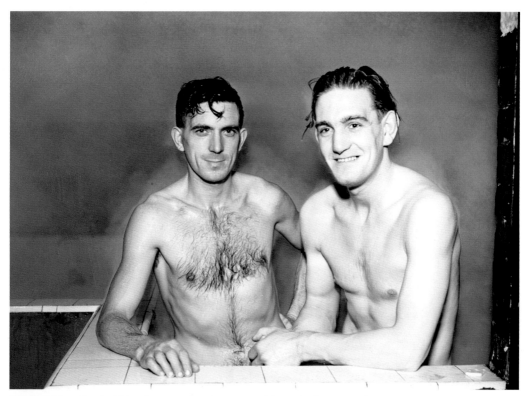

Brentford's Harry Bamford (L) and a teammate enjoy a steamy brine bath. Oliver was a full-back and centre-half, making 18 appearances for Brentwood between 1938 and 1948.
1st March, 1946

Tommy Lawton, Chelsea. Despite having flat feet, Lawton had great ability as a striker. He became renowned for his pace, heading skills and two-footed efficiency, In addition to Chelsea (1945–47), he also played for Notts County (1947–51), Brentford (1951–53) and Arsenal (1953–55).

17th August, 1946

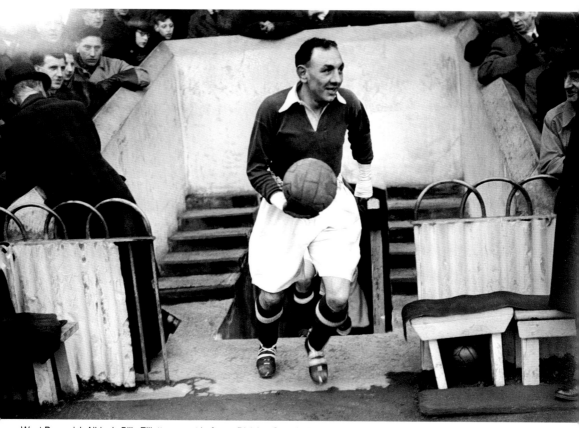

West Bromwich Albion's Billy Elliott runs out before a Division One clash against Tottenham Hotspur. The match ended in defeat for Albion, with 2–0 victory for their North London opponents.

4th January, 1947

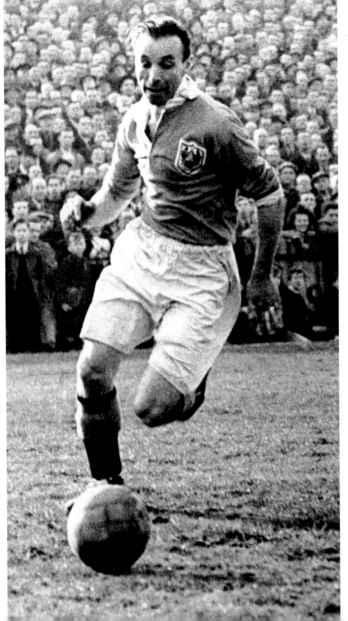

Stanley Matthews, Blackpool outside-right, in action against Fulham. Widely regarded as one of the finest players of the English game, he was the first player to be knighted while still playing. At the age of 50, he was still fit enough to be playing in the top flight. He played for England from 1934 to 1957, earning 54 caps and scoring 11 goals.

28th February, 1948

Yeovil Town player-manager Alec Stock at work in his office immediately after training. Stock played as an inside-forward for Tottenham Hotspur, Charlton Athletic and QPR before the Second World War. He took on the role of player-manager at Yeovil Town in 1946, later going on to manage Leyton Orient (1949–59), AS Roma, QPR (1959–65), Luton Town (1968–72), Fulham (1972–76) and AFC Bournemouth (1979–80).

26th January, 1949

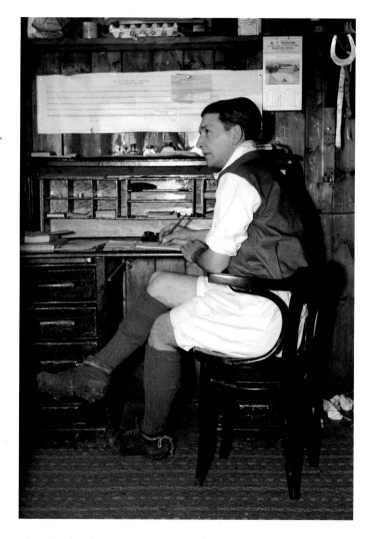

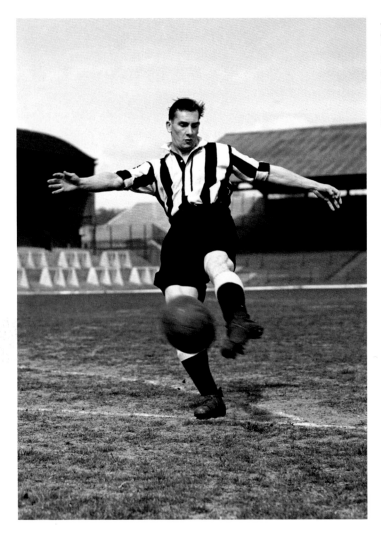

Jackie Milburn, Newcastle United centre-forward. Known to fans as 'Wor Jackie' ('our Jackie' in the Geordie dialect), he remains the club's second highest League and Cup goal-scorer, notching up 200 goals – just six less than Alan Shearer.

29th April, 1950

Len Shackleton, Sunderland inside-forward and outside-left. Shackleton's entertaining antics on the pitch earned him the title of the 'Clown Prince of Football'. He back-heeled penalty kicks into the goal, sat on the ball to annoy defenders who couldn't dispossess him and mocked opponents by playing one-twos with the corner flag. In 348 League games for Sunderland (1948–57), he scored 101 goals.
1st March, 1950

Jackie Vernon, West Bromwich Albion. An Irish striker, Vernon began his career at Belfast Celtic before joining West Bromwich Albion in 1947. He made 190 appearances in his five years at the club. A dual international player, Vernon played for both Ireland and England.
27th April, 1950

West Ham United manager Ted Fenton (R) explains a tactical point to Harry Kinsell (C) while Kinsell receives a massage from trainer W. Moore. Fenton managed West Ham from 1950 to 1961 and was responsible for setting up the Youth Academy to train young players. Kinsell was a fast left-back, renowned for his agility and quick-thinking.

4th February, 1952

Duncan Edwards, England wing-half. One of Busby's Babes, Edwards became the youngest player to play in the Football League First Division on his debut against Cardiff City on 4th April, 1953. Shown here shortly before winning his first international cap on 2nd April, 1955, he played for England in 18 matches, scoring five goals.
31st March, 1955

Facing page: Manchester City's Dave Ewing (L) and Bill Leivers (R) help goalkeeper Bert Trautmann off the pitch after their 3–1 victory. Trautmann had broken his neck making a save at the feet of Birmingham City's Peter Murphy.
5th May, 1956

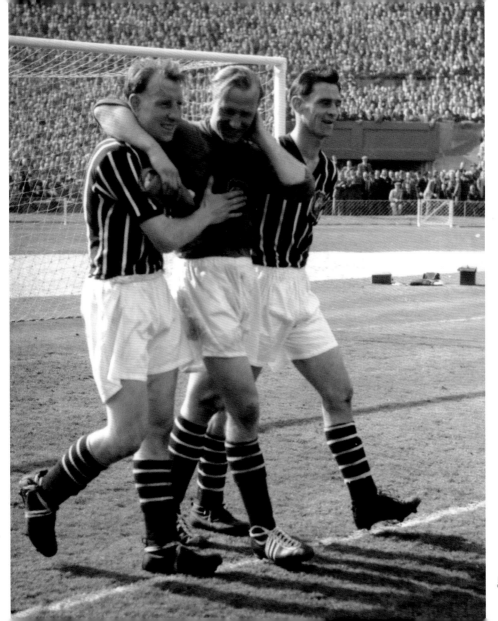

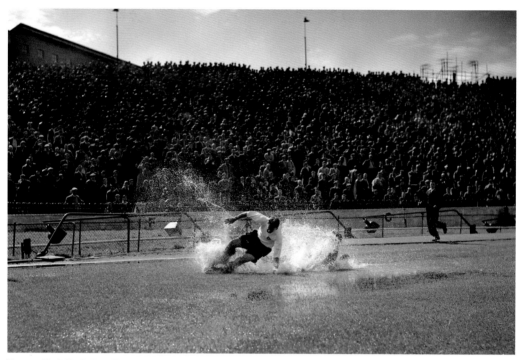

Preston North End's Tom Finney splashes through a puddle in a Division One clash against Chelsea at Stamford Bridge. On 31st July, 2004, the now-knighted Sir Tom unveiled a water feature sculpture called 'The Splash' outside The National Football Museum. It was inspired by this picture, which was acclaimed as the 1956 Sports Photograph of the Year.
25th August, 1956

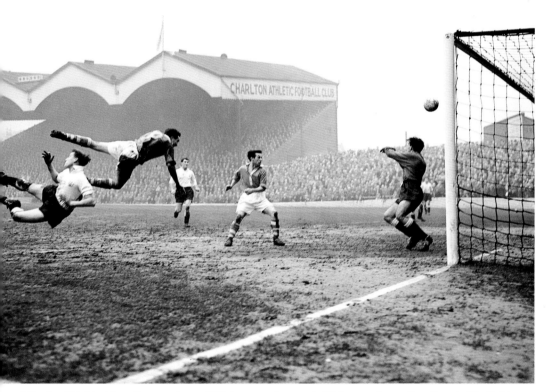

Charlton Athletic's Johnny Summers (second L) brings a great save out of Fulham goalkeeper Tony Macedo (R) with this flying header. Fulham's Jim Langley (L) is the beaten full-back.
29th January, 1958

England goalkeeper Eddie Hopkinson makes a flying save during a friendly against Italy. Hopkinson played for Oldham Athletic (1951–52) and Bolton Wanderers (1952–70), and holds the club record at Bolton for 519 appearances. He earned 14 caps for the England national squad, and was England's reserve goalkeeper at the 1958 FIFA World Cup.

6th May, 1959

Facing page: Danny Blanchflower of Tottenham Hotspur casts a critical eye over his boots. Widely considered to be one of the greatest players in Spurs' history, Blanchflower was an excellent right-half and master tactician. He captained the club during its double-winning season in 1961.

26th September, 1958

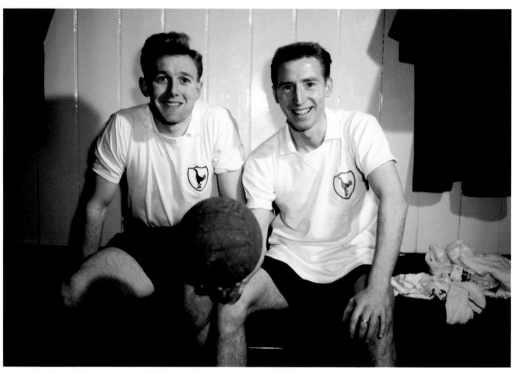

Terry Medwin (L) and Cliff Jones, Tottenham Hotspur. Welsh winger Medwin played for the club from 1956 to 1963, scoring 72 goals in 215 League matches. He also made 30 international appearances for Wales. Fellow Welshman Jones was considered by many to be the best left-winger in the world during the 1960–61 season, when Spurs won the First Division title and the FA Cup. Jones was capped 59 times for Wales.

1st September, 1959

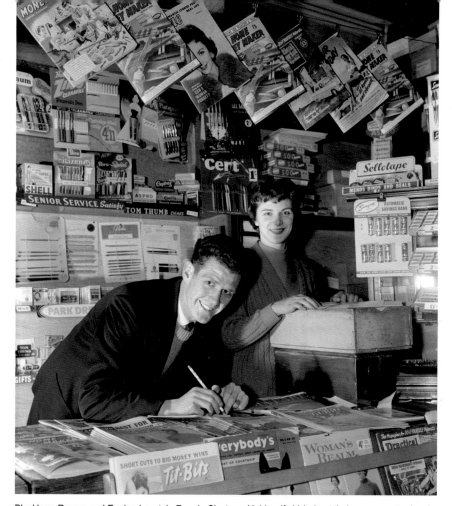

Blackburn Rovers and England captain Ronnie Clayton with his wife Valerie at their newsagents shop in Darwen, Lancashire. Clayton made 581 League appearances for Blackburn Rovers from 1950 to 1969. He later became a player-manager at Morecambe.

23rd October, 1959

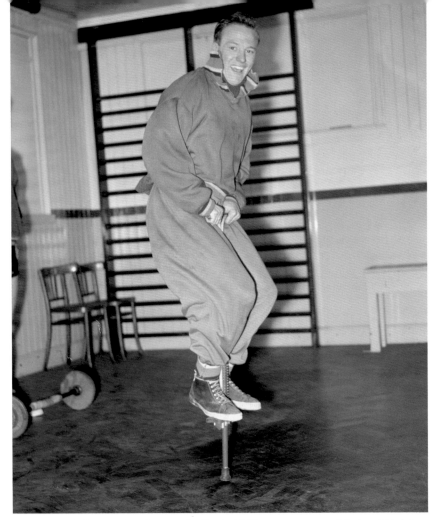

Chelsea's Frank Blunstone bounds across the Stamford Bridge gym on a pogo stick. An outside-left, he played for the club from 1953 to 1964, notching up 47 goals in 317 League appearances.

28th January, 1960

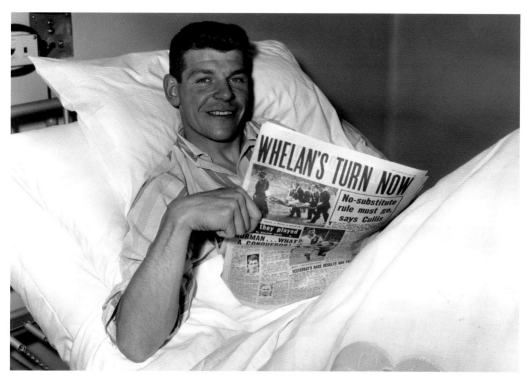

Blackburn Rovers' David Whelan rests in hospital recovering from a broken leg. The full-back's injury took place during the first half of the 1960 FA Cup Final against Wolverhampton Wanderers. Rovers lost 3–0 to Wolves. After recovering from his leg injury, Whelan was sold to Crewe Alexandra FC. He later retired and set up the JJB Sports chain of sporting goods stores.
7th May, 1960

Bobby Robson, West Bromwich Albion. As an inside-forward for Albion, Robson made 239 appearances between 1956 and 1962. He later played for Fulham and Vancouver Royal. He was capped 20 times for England (1957–62). Many years later, as the manager of the team, he took England to the semi-final of the 1990 World Cup.

2nd June, 1960

Arsenal goalkeeper Jack Kelsey stopped an incredible six shots simultaneously during pre-season training. Kelsey was a Welsh international, and he is generally regarded as one of the most impressive goalkeepers ever to play for Wales.
16th August, 1960

Joe Baker (L) and Denis Law are able to see the funny side of their life-threatening car crash, upon returning to training at Torino. Baker drove their vehicle the wrong way around a roundabout, hitting the curb and tipping the car over.
24th April, 1962

Facing page: Walter Winterbottom, England manager. Shown here during a training session for the 1962 World Cup, Winterbottom resigned after the nation's defeat in the tournament. He was succeeded by Alf Ramsey.
1st March, 1962

Terry Paine, Southampton forward, prepares to shoot during a training session. He made 713 appearances for the club as a winger and midfield player. Capped 19 times for England, he was also part of the 1966 World Cup-winning team.
1st November, 1963

Bobby Moore, West Ham United. A Hammers defender from 1958 to 1974, Moore held the captaincy for over a decade. He was also the England captain in the 1966 World Cup, leading the team to a 4–2 victory over West Germany.
1st February, 1964

England's Terry Venables practises his splits at Stamford Bridge in preparation for a friendly against Belgium. During the 1960s and '70s, Venables played for several clubs including Chelsea, Tottenham Hotspur, Queens Park Rangers and Crystal Palace. He was also awarded two caps for England appearances.

19th October, 1964

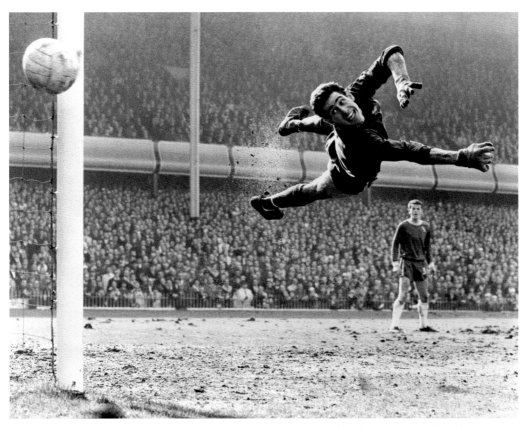

Chelsea goalkeeper Peter Bonetti makes a flying save, watched by teammate Eddie McCreadie. The action took place at Villa Park during the 1965 FA Cup Semi-Final against Liverpool. The Reds won 2–0, and defeated Leeds 2–1 in the Final.
29th March, 1965

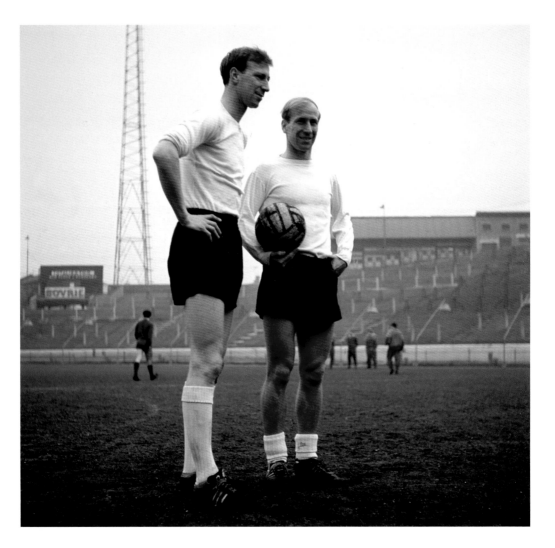

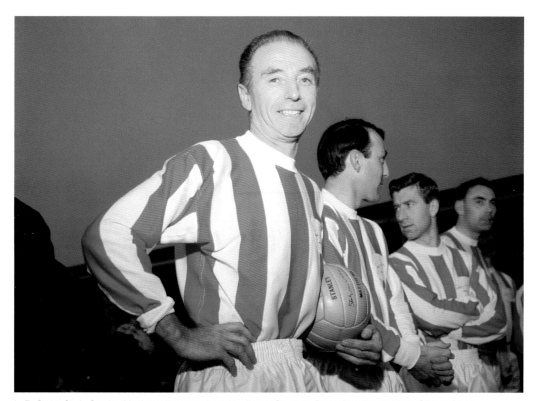

L–R: Stoke City's Stanley Matthews lines up alongside Jimmy Greaves, Bryan Douglas and Alan Gilzean for his testimonial match. It took place at Stoke City's Victoria Ground, some 33 years after the winger made his debut.
28th April, 1965

Facing page: England players Jack (L) and Bobby Charlton take a break in training at Stamford Bridge, Chelsea. Both brothers would go on to receive World Cup medals for their roles in the victorious 1966 England team.
8th April, 1965

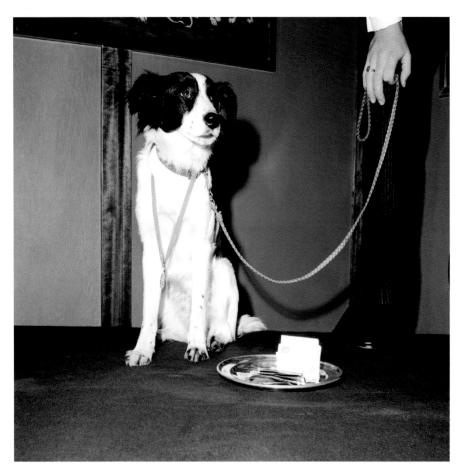

Pickles the Collie, who discovered the stolen Jules Rimet Trophy under a holly bush outside his owner's house in South London in 1966. He's shown wearing the silver medal that was presented to him by the National Canine Defence League, with his reward on a plate in front of him.
1st April, 1966

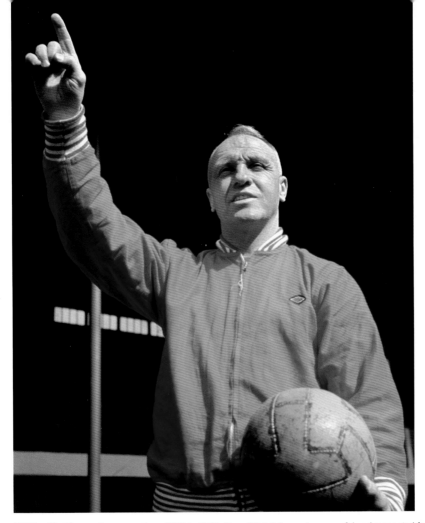

Bill Shankly, Liverpool manager from 1959 to 1974. One of Britain's most successful and respected football managers, Shankly took the Reds from the Second Division to the top flight of English football. He was awarded an OBE in 1974.
1st August, 1966

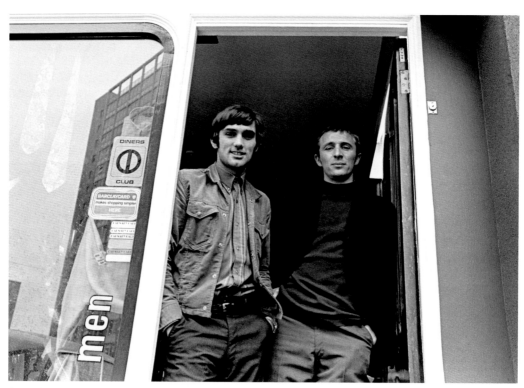

George Best (L) and Mike Summerbee standing inside their men's clothing boutique. Despite playing for rival clubs – Best for Manchester United and Summerbee for Manchester City – the two players were great friends. In 2009, Summerbee became Manchester City's first Club Ambassador.

1st June, 1967

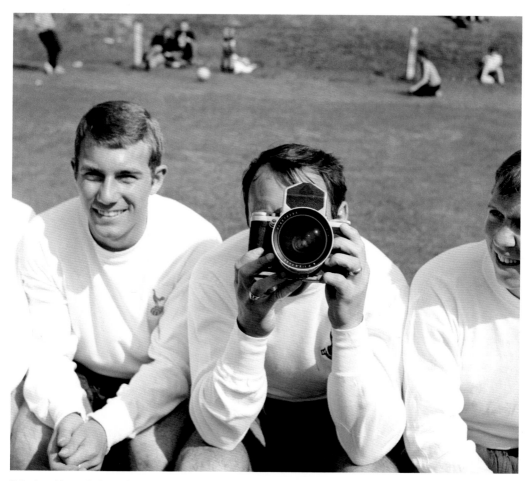

Tottenham Hotspur's Jimmy Greaves (C) plays about with a camera as his teammates look on. Greaves played for Spurs from 1961 to 1970, scoring 220 goals in 321 First Division appearances. He is the highest goal-scorer in the club's history.
7th August, 1967

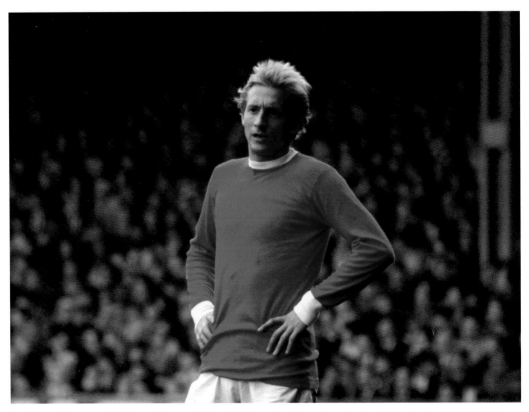

Denis Law, Manchester United centre-forward. A Scottish international, Law played for the Red Devils from 1962 to 1973. He scored 237 goals in 409 League appearances, earning himself two nicknames by United supporters – 'The King' and 'The Lawman'.

30th September, 1967

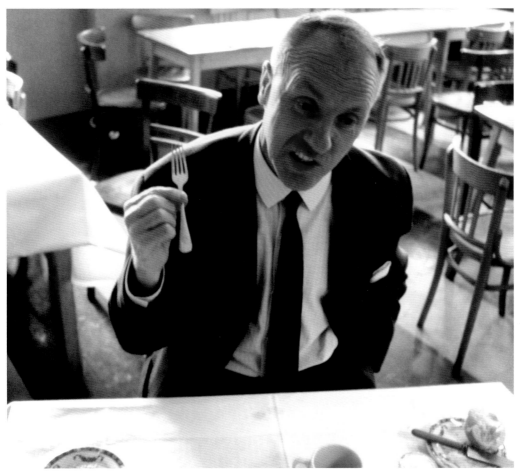

Liverpool manager Bill Shankly at lunch in 1968. By this time, he had managed Liverpool for nine years and guided its players from the Second Division to the top flight, winning the FA Cup in 1964–65 and the League title in 1965–66.
1968

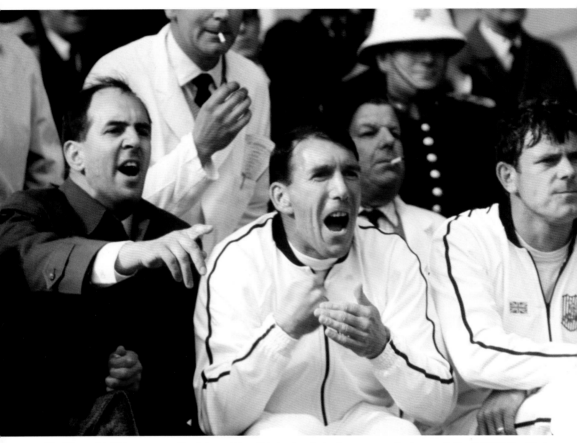

West Bromwich Albion manager Alan Ashman (L) and his track-suited colleagues urge the team on in the 1968 FA Cup Final against Everton. The result was a victory for Albion, with Jeff Astle scoring a single goal for the club during extra time.
18th May, 1968

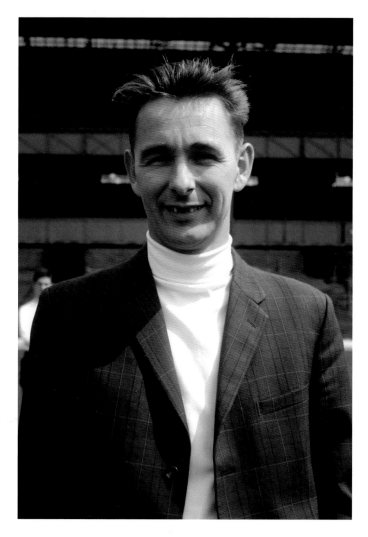

Brian Clough, Derby County manager from 1967 to 1973. Widely considered to be one of the greatest managers in the English game, Clough revived the fortunes of Derby, elevating them from the Second Division back up to the top flight in the 1969–70 season. As manager of Nottingham Forest (1975–93), he led the club to consecutive European Cup victories in 1979 and 1980. Despite his success, he was never offered the job of England manager.

1st July, 1969

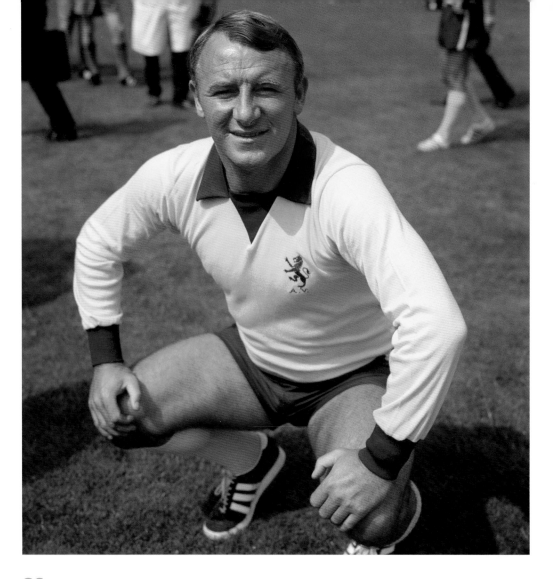

Facing page: Tommy Docherty, manager of Aston Villa from 1968 to 1970. Pictured here at Villa Park, he spent 13 months at the club before being sacked when Villa ended up at the bottom of the Second Division in the 1969–70 season. He went on to manage several other clubs, including Manchester United (1972–77), Derby County (1977–79) and Queens Park Rangers (1979–80).
1st July, 1969

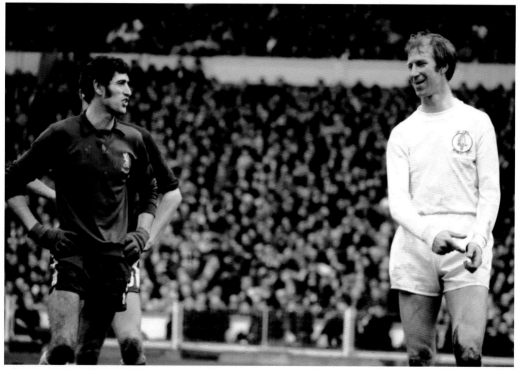

Chelsea's goalkeeper Peter Bonetti (L) and Leeds United's Jack Charlton at the FA Cup Final in 1970. It ended in a 2–2 draw, but the replay on 29th April resulted in a 2–1 win for Chelsea.
11th April, 1970

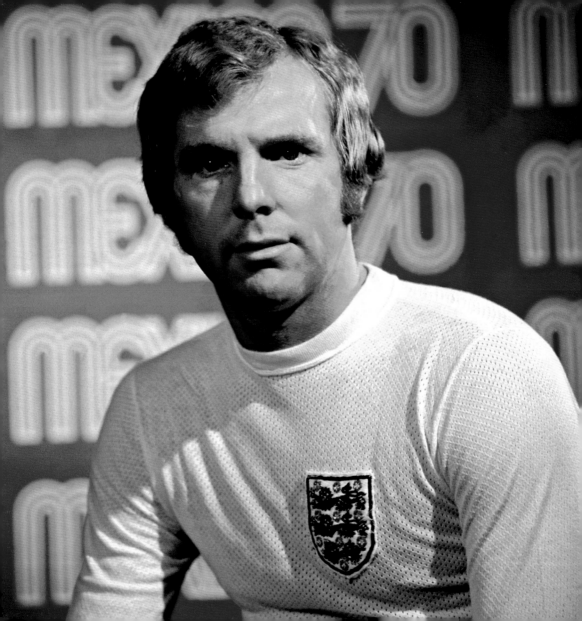

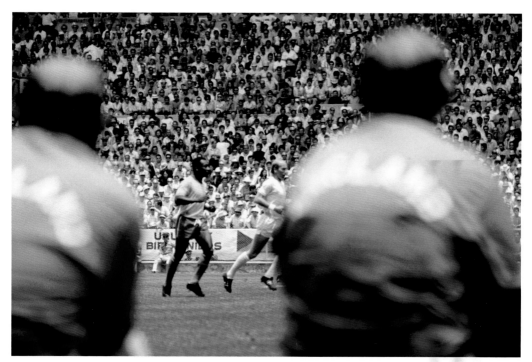

Pelé of Brazil (L) and Bobby Charlton of England (R) seen from the England bench as the English squad take on Brazil in the 1970 World Cup. The South American team beat their opponents 1–0.
7th June, 1970

Facing page: Bobby Moore, England captain. The legendary Brazilian striker Pelé claimed that Moore was the greatest defender he had ever played against.
1st May, 1970

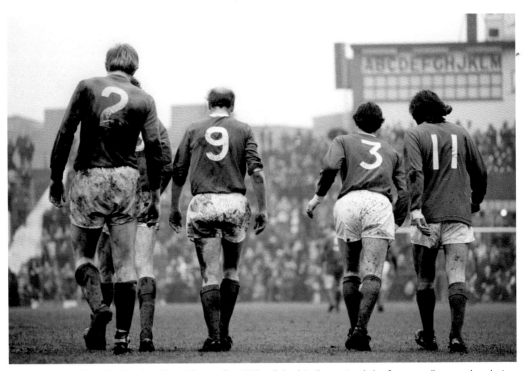

Manchester United's Bobby Charlton (9) and George Best (11) walk back to the centre circle after conceding a goal against Ipswich Town. United rose to the challenge, defeating Ipswich 3–2.
24th April, 1971

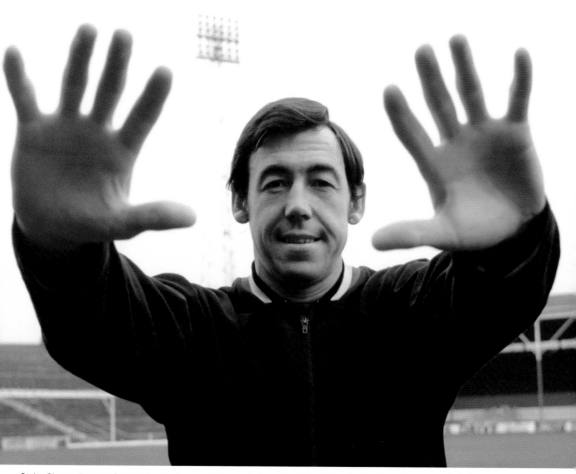

Stoke City goalkeeper Gordon Banks shows off his greatest assets at the Brittannia Stadium. Banks was Stoke's goalkeeper from 1967 to 1972. A member of the 1966 England squad, he is regarded as one of the best goalkeepers of the 20th century, **30th April, 1971**

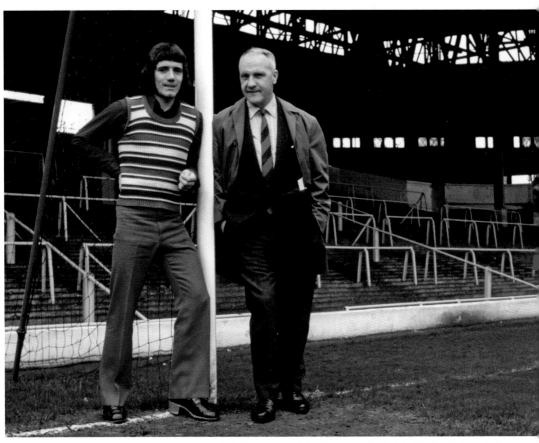

Liverpool manager Bill Shankly (R) with new signing Kevin Keegan at Anfield. Keegan made his debut for the Reds on 14th August, 1971 against Nottingham Forest. The striker scored his first goal for the club after 12 minutes.
24th May, 1971

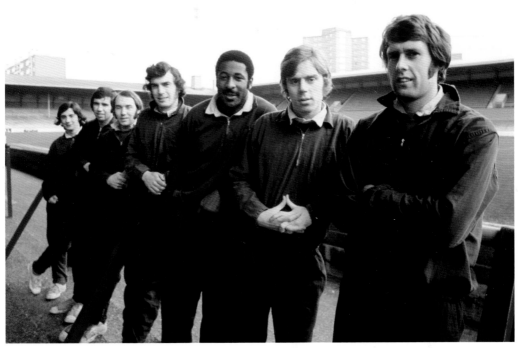

R–L: West Ham United's Geoff Hurst, Harry Redknapp, Clyde Best, Trevor Brooking, Bryan 'Pop' Robson, Ronnie Boyce and John Ayris line up on the terraces at Upton Park.
1st October, 1971

Gordon Banks (L) and George Eastham (R) of Stoke City celebrate victory in the 1972 League Cup Final. Eastham was the scorer of the winning goal in the Stoke City v Chelsea clash. The final result was 2–1.

4th March, 1972

Facing page: England captain Bobby Moore shows off a stylish shirt from his line of men's fashion products.

1st July, 1972

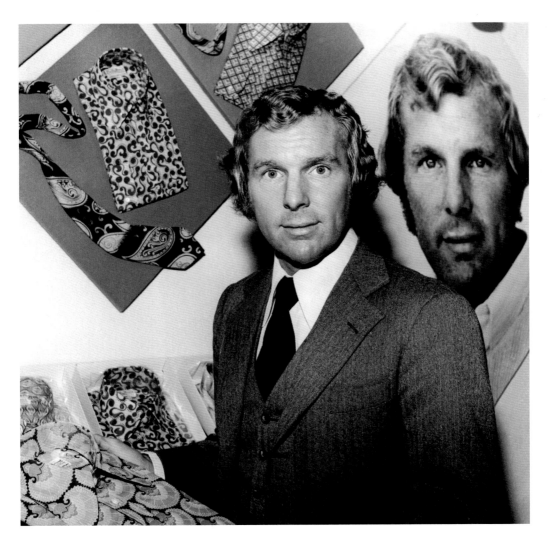

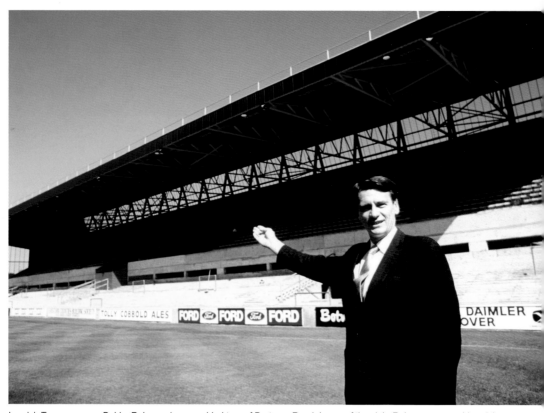

Ipswich Town manager Bobby Robson gives a guided tour of Portman Road, home of the club. Robson managed Ipswich from 1969 to 1982, building his reputation as a successful manager. In his time there, the club twice finished as League runners-up, and made regular appearances in European competitions, winning the UEFA Cup in 1981.
1st August, 1972

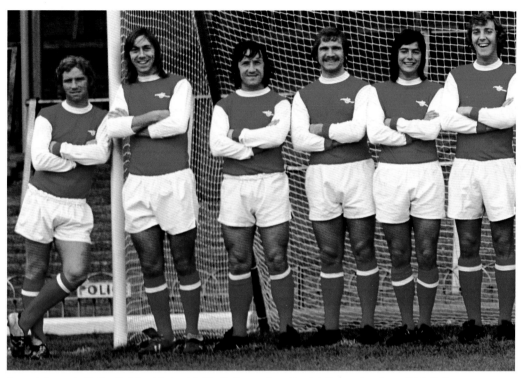

Arsenal players, L–R: Alan Ball (in white boots), Charlie George (in red boots), George Armstrong, Eddie Kelly, Peter Marinello and Sammy Nelson. This team led Arsenal to a second place position in the League for the 1972–73 season.
1st August, 1972

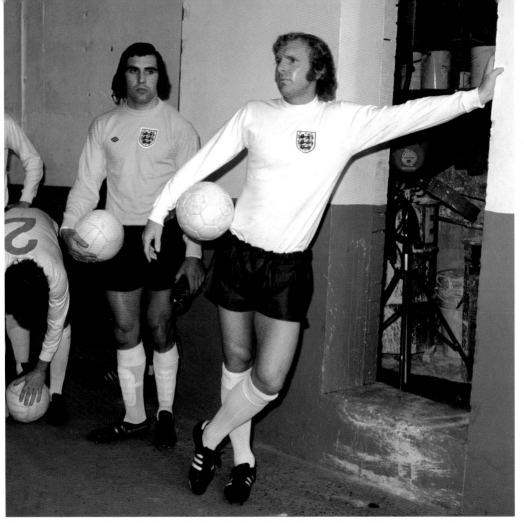

England captain Bobby Moore (R) relaxes in the Wembley tunnel before England take on Wales in the Home International Championship as goalkeeper Peter Shilton (L) looks on. The result was a 3–0 victory for England.
15th May, 1973

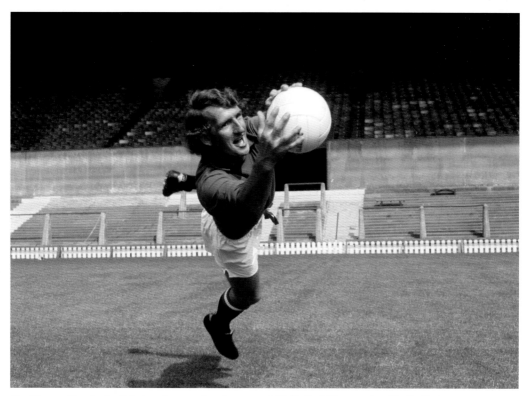

Alex Stepney, Manchester United goalkeeper, dives for a save at Old Trafford. Stepney played for the Red Devils from 1966 to 1978. He was United's keeper in 1970 when they became the first English club to win the European Cup, defeating Benfica 4–1.

1st August, 1973

Derby County manager Brian Clough in the *World of Sport* studios in 1973. He is pictured here making his debut appearance as a football analyst on ITV's *On The Ball* programme.
23rd August, 1973

England captain and striker Emlyn Hughes (L) and manager Don Revie at a training session before the European Championship Qualifier game between England and Czechoslovakia in 1974. The result was a 3–0 win for England. Hughes, made 62 appearances for England between 1969 and 1980.

28th October, 1974

L–R: England's Emlyn Hughes waits for the Brazilian national anthem to end, alongside teammates Brian Greenhoff, Phil Neal, Trevor Francis and Dave Watson, at a friendly at the Maracan Stadium in 1977. The result was a 0–0 draw.

8th June, 1977

Facing page: Nottingham Forest goalkeeper Chris Woods acknowledges the cheers of the Forest fans at the League Cup Final in 1978. By keeping Liverpool out for 120 minutes, he forced a replay. The replay result was a 1–0 victory for Forest.

18th March, 1978

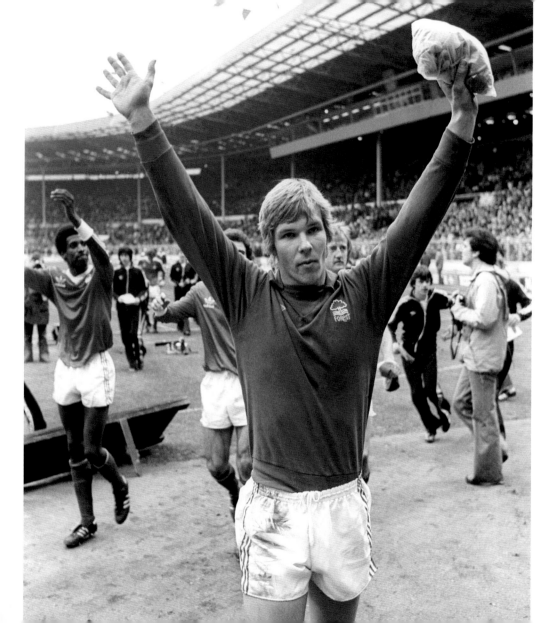

Tottenham Hotspur's Osvaldo Ardiles reads a review of his performance in the 1978 World Cup in a copy of *Onze* at White Hart Lane. A talented midfielder, Ardiles had recently been signed by the club from Huracán.
1st August, 1978

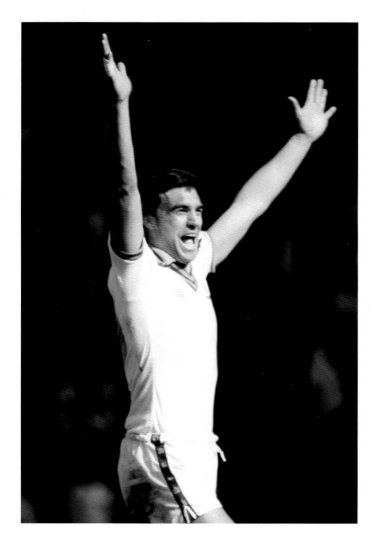

West Ham United's Trevor Brooking celebrates scoring the winning goal in the 1980 FA Cup Final against Arsenal. The result was 1–0 for the Hammers. Brooking played for England from 1974 to 1982, making 47 appearances for his country.
10th May, 1980

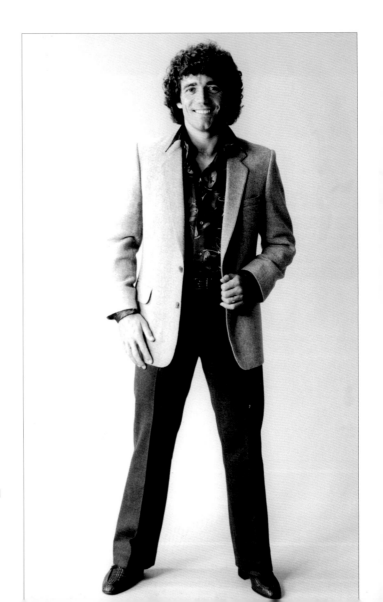

Kevin Keegan, recently signed to
Southampton after three years at
Hamburg, models a sports jacket and
flannel trousers, both from the Kevin
Keegan collection at Fenton shops.
1st September, 1980

102

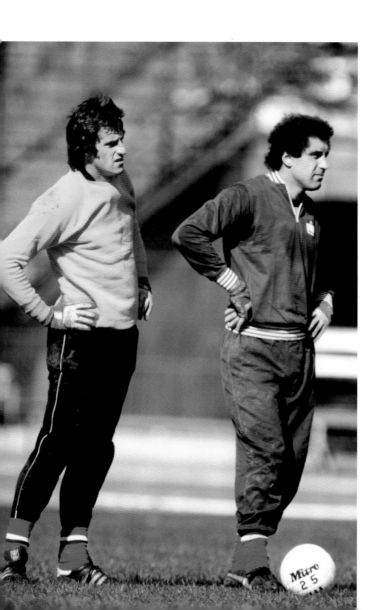

England goalkeepers Ray Clemence (L) and Peter Shilton in training for the 1980 World Cup Qualifier against Romania. The game was a 2–1 victory for the Eastern European side.
15th October, 1980

103

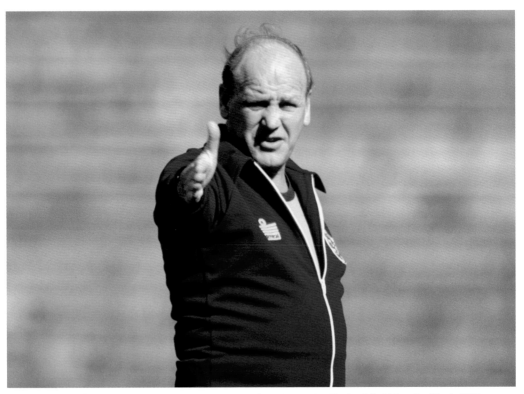

Ron Greenwood, England manager, during a training session for the Romania v England World Cup Qualifier in 1980. Greenwood managed the England squad from 1977 until 1982.

15th October, 1980

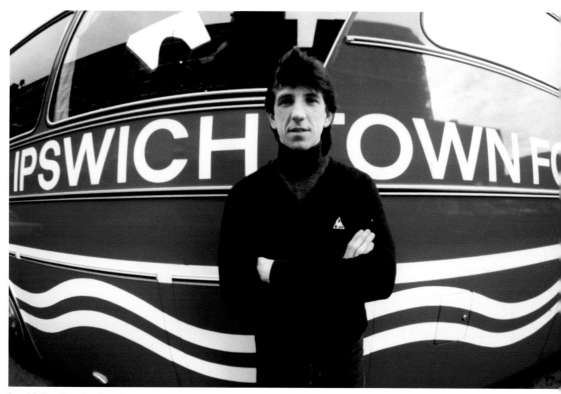

Ipswich Town's striker Paul Mariner stands in front of the team bus. Mariner played for Ipswich from 1976 to 1984, making 260 League appearances for the club in which he netted 96 goals.
6th February, 1981

Chelsea goalkeeper Petar Borota tries to pick a pair of boots to wear while testing the new Omniturf surface at Loftus Road, home of Queens Park Rangers. Borota played for Chelsea from 1979 to 1982, making 107 League appearances.
24th June, 1981

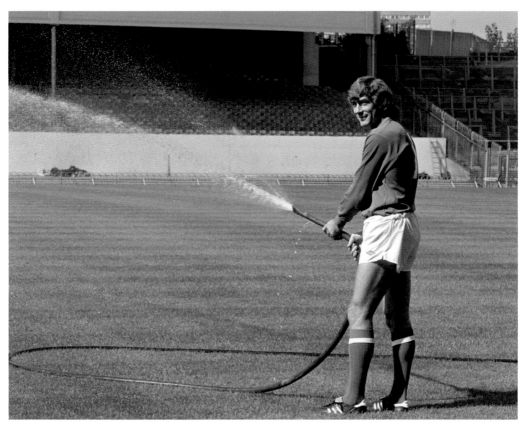

Arsenal goalkeeper Pat Jennings fools around with a hose during the club's pre-season photocall at Highbury. Jennings played for North London rivals Tottenham Hotspur (1964–77) before joining Arsenal (1977–85), winning the FA Cup with both teams.

25th August, 1981

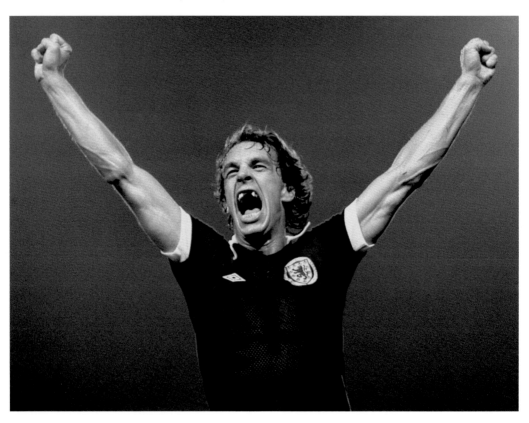

Scotland forward Joe Jordan celebrates scoring the opening goal in the World Cup Qualifier between Scotland and Sweden in 1981. The final result was a 2–0 victory for Scotland.

9th September, 1981

Manchester United manager Ron Atkinson (L) and chairman Martin Edwards (R) with new signing Bryan Robson at Old Trafford. Midfielder Robson played for the club from 1981 to 1984, making 345 League appearances.

2nd October, 1981

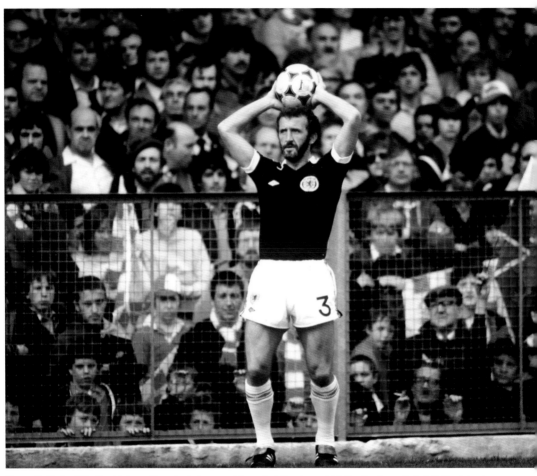

Danny McGrain of Scotland takes a throw-in during a match against Sweden, which Scotland won 2–0. A Celtic defender, McGrain played for his country from 1973 to 1982, making 62 appearances.
9th October, 1981

England's Paul Mariner (C) hooks the ball back across the goal, watched by (L–R) Scotland's Paul Hegarty, Alan Rough, Willie Miller and Danny McGrain in a Home International Championship clash. The final score was England 1, Scotland 0.
29th May, 1982

Graham Taylor, Watford manager, watches the match as Watford take on West Bromwich Albion. Taylor led Watford from 1977 to 1987 and took on the job of England manager from 1990 to 1993.

11th September, 1982

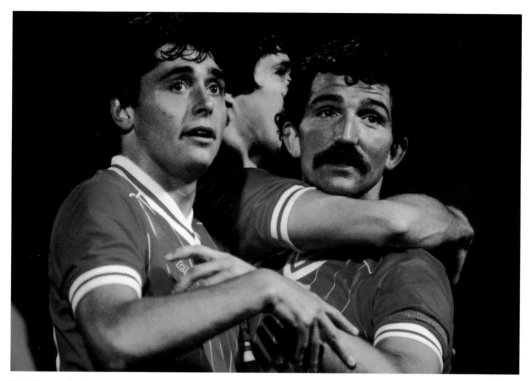

L–R: Liverpool's Michael Robinson, Alan Hansen and Graeme Souness celebrate a 1–0 victory over Dinamo Bucuresti in the Semi-Finals of the Champions League in 1984.
10th April, 1984

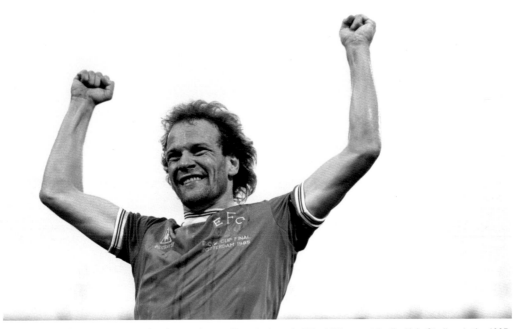

Everton's Andy Gray celebrates scoring the opening goal in a clash against Rapid Vienna at the De Kuip Stadium in the 1985 European Cup Winners' Cup Final. The result was a 3–1 victory for Everton.
15th May, 1985

Facing page: Bloodied but unbowed, defender Alvin Martin of West Ham United soldiers on after a messy pitch collision. Martin's solid defending helped the Hammers achieve their most successful season ever in 1985–86, finishing in third place behind Everton and the League winners, Liverpool.
10th September, 1985

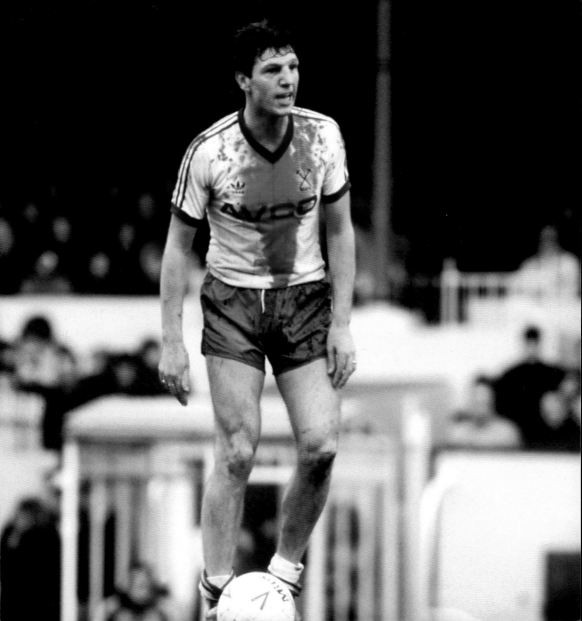

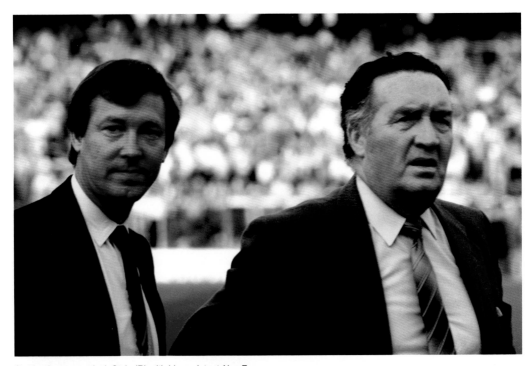

Scotland manager Jock Stein (R) with his assistant Alex Ferguson. This picture was taken at the World Cup Qualifier between Wales and Scotland on 10th September, 1985. Stein, Scotland manager since 1978, died from a heart attack later on that day.

10th September, 1985

Facing page: Referee Alan Robinson shows that even refs are human, laughing at what appears to be the world's funniest joke.

1st October, 1985

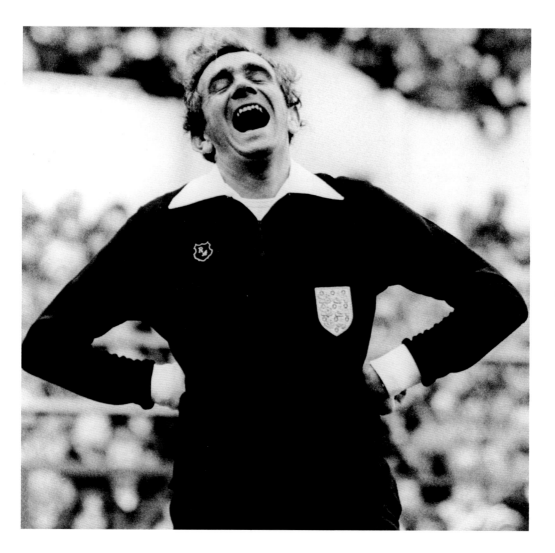

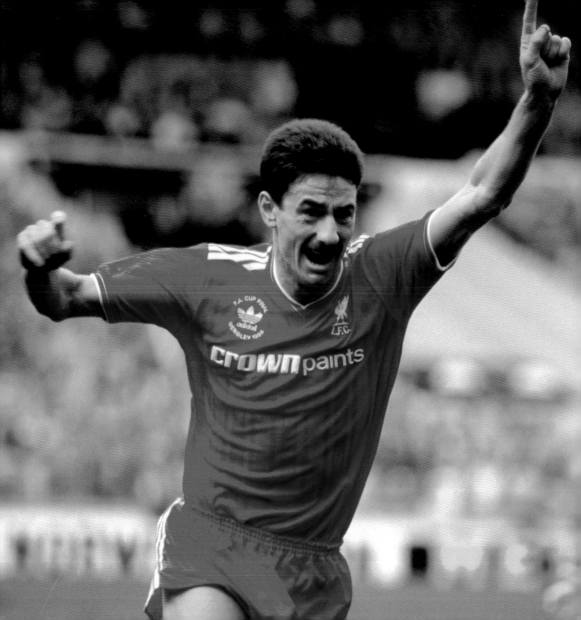

England's John Barnes (L) and Gary Lineker by the pool after a training session for the 1986 World Cup in Mexico. Lineker had sprained his wrist and competed with it strapped up. England lost 1–0 to Portugal in their opening game of the season.
1st June, 1986

Facing page: Liverpool's Ian Rush celebrates scoring against Everton in the 1986 FA Cup Final. The Reds secured a 3–1 victory over their local rivals.
10th May, 1986

Striker Mirandinha (L) and midfielder Paul Gascoigne, Newcastle United. The pair celebrate the Magpies' 2–0 victory over Nottingham Forest at the City Ground.
1st January, 1988

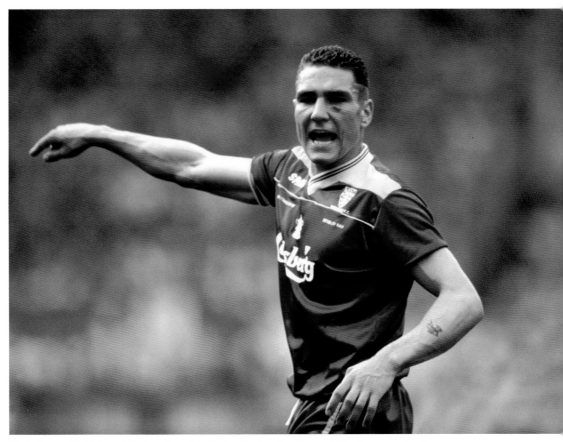

Vinnie Jones, Wimbledon midfielder, at the 1988 FA Cup Final against Liverpool. The Dons were victorious over the Reds, with Jones helping the team to secure a 1–0 result.
14th May, 1988

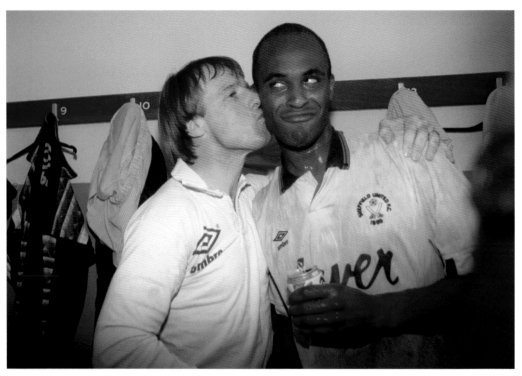

Sheffield United manager Dave Bassett (L) kisses striker Tony Agana after United secure promotion to Division One by defeating Leicester City 5–2.
5th May, 1990

Facing page: England's Paul Gascoigne with his head in his hands, crying after defeat by West Germany in the 1990 World Cup Semi-Final in Turin.
4th July, 1990

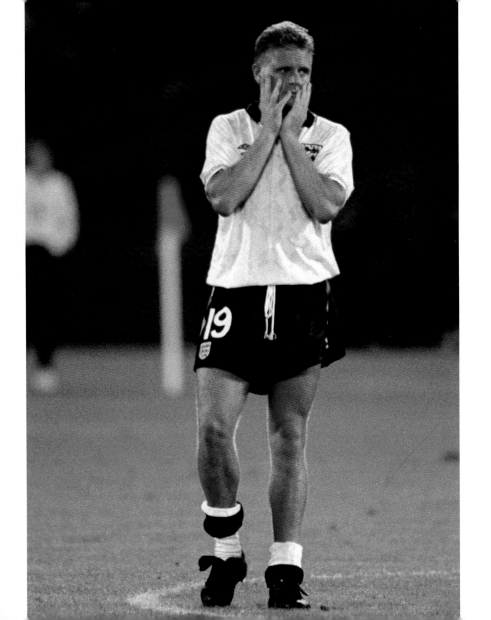

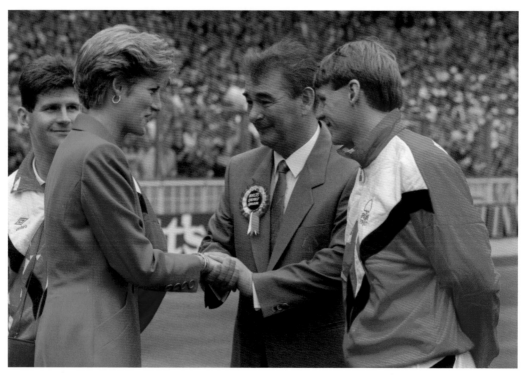

HRH Diana, The Princess of Wales, meets Nottingham Forest's Brian Laws (L) manager Brian Clough (C) and captain Stuart Pearce (R) before the 1991 FA Cup final with Tottenham Hotspur. Forest lost to Spurs, who clinched a 2–1 victory.
18th May, 1991

Facing page: Liverpool goalkeeper Bruce Grobbelaar lets off steam during training for a UEFA Cup match against Swarovski Tirol-Innsbruck.
27th November, 1991

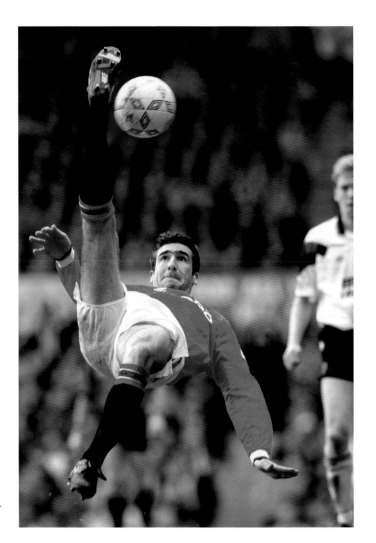

Manchester United's agile forward Eric Cantona tries an overhead kick in a 1993 clash against Aston Villa at Old Trafford. Despite the Frenchman's efforts, the match ended in a 1–1 draw.
14th March, 1993

Striker David Speedie of Leicester City (L) comes face to face with Manchester United goalkeeper Peter Schmeichel in a Coca Cola Cup Third Round match. The game was a big win for United, who annihilated Leicester in a 5–1 victory.
27th October, 1993

Everton's Duncan Ferguson celebrates his club's 1–0 victory over Manchester United in the 1995 FA Cup Final with a blue nose. This match was the 50th Cup Final since the end of the Second World War.

20th May, 1995

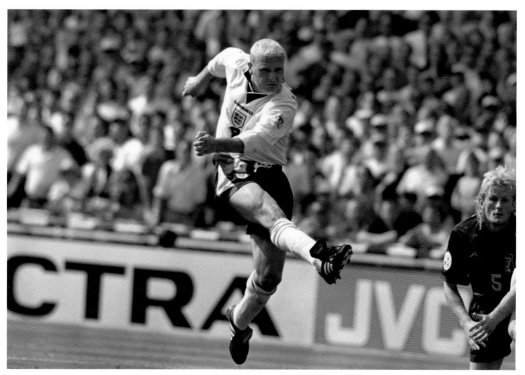

Paul Gascoigne (L) scores England's second goal in spectacular fashion as Scotland's Colin Hendry can only look on, during the Euro 96, Group A match at Wembley Stadium. This goal clinched a 2–0 win over Scotland.

15th June, 1996

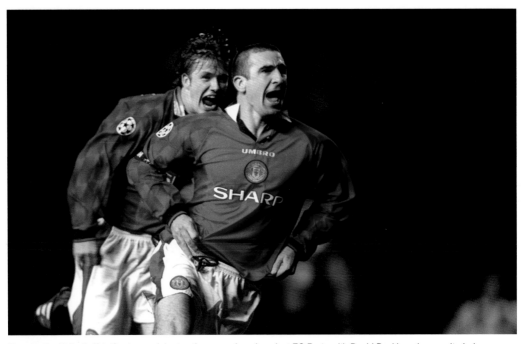

Manchester United's Eric Cantona celebrates the second goal against FC Porto with David Beckham in pursuit, during a UEFA Champions League clash. The final result was a resounding 4–0 victory for the Red Devils.

5th March, 1997

England's blood-stained captain Paul Ince (C) rallies Tony Adams (R) and Sol Campbell (L) at a World Cup Qualifier against Italy. Ince received a head injury in the first half, but played on to lead England to a 0–0 draw and through to the World Cup Finals.

11th October, 1997

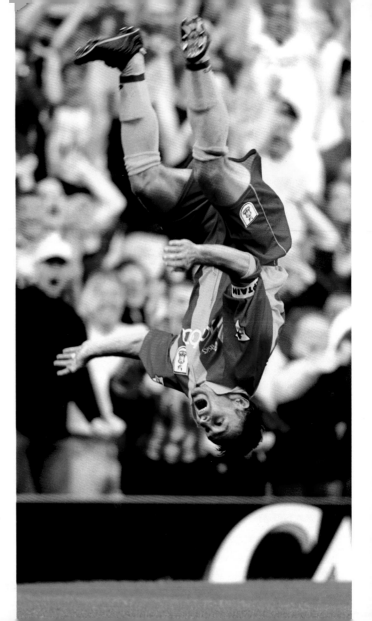

Bradford City's Peter Beagrie
celebrates after scoring from the
penalty spot in a 1–1 clash against
Sheffield Wednesday at Valley Parade.
The left-winger played for the club
from 1997 to 2001.
14th August, 1999

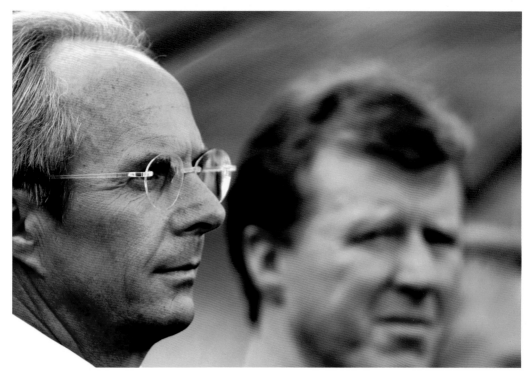

England manager Sven Goran Eriksson (L) and coach Steve McClaren at the FIFA World Cup Quarter Final in 2002 as England take on Brazil. Despite a strong performance from the English squad, the South Americans won 2–1.
21st June, 2002

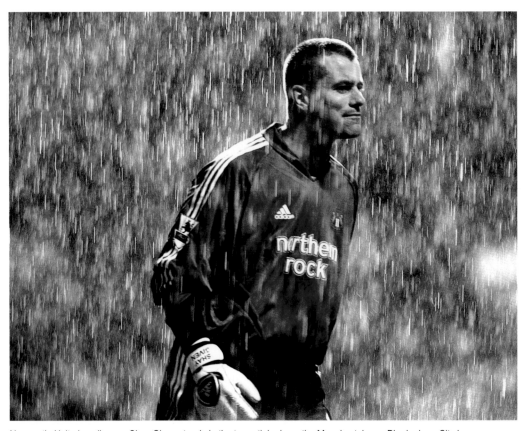

Newcastle United goalkeeper Shay Given stands in the torrential rain as the Magpies take on Birmingham City in a Premiership fixture at St James' Park. The outcome of this rain-sodden game was a 2–1 win for Newcastle.
1st January, 2005

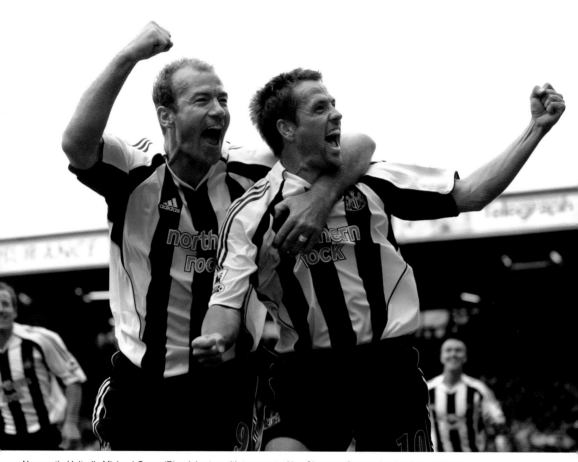

Newcastle United's Michael Owen (R) celebrates with teammate Alan Shearer after scoring his first goal for his new club. It was the second goal in an away clash against Blackburn Rovers, ending with a 3–0 win for the Magpies.
18th September, 2005

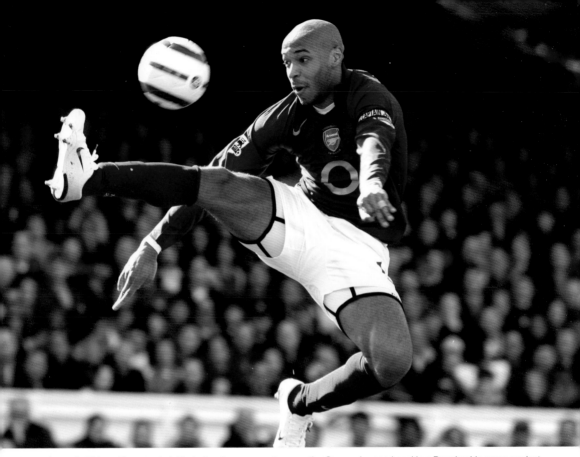

Arsenal's Thierry Henry controls the ball as he prepares to score the Gunners' second goal in a Premiership game against Aston Villa at Highbury. The result was an impressive 5–0 win for the North London club.

1st April, 2006

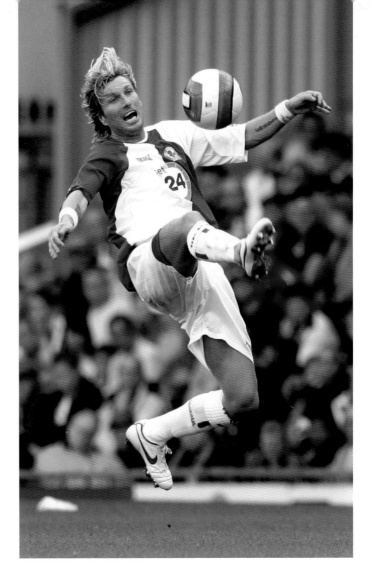

Robbie Savage, Blackburn Rovers midfielder. Savage takes to the air in a clash against Chelsea at Ewood Park. He played for Rovers during 2005–08, making 76 League appearances.
27th August, 2006

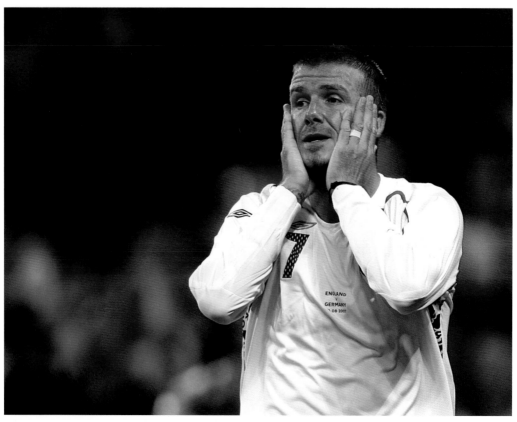

England's David Beckham stands dejected after a missed goal-scoring opportunity in an international friendly against Germany at Wembley Stadium in 2007.

22nd August, 2007

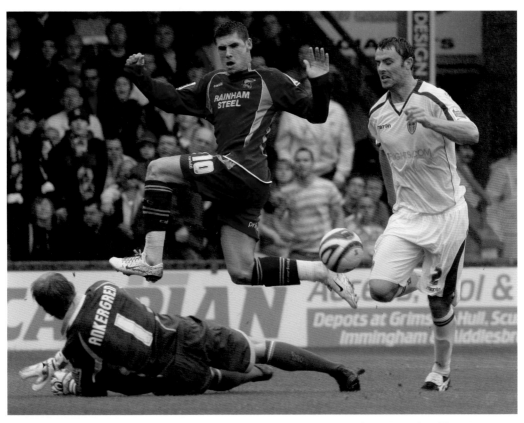

Scunthorpe United's Gary Hooper jumps over Leeds goalkeeper Casper Ankergren as Frazer Richardson (R) watches on during the Coca-Cola Football League One match at Glanford Park, Scunthorpe, North Lincolnshire.

9th August, 2008

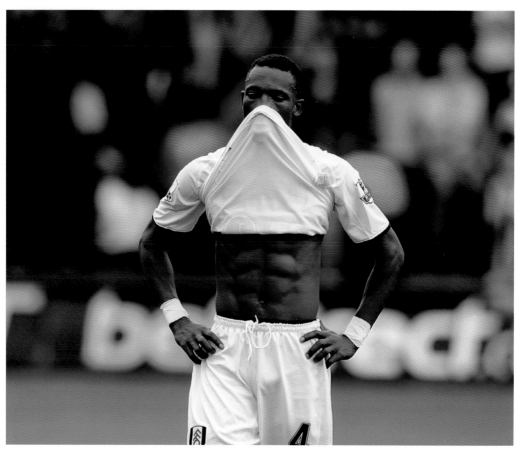

Fulham's John Pantsil looks dejected (although still managing a fine display of abs) after the final whistle in the Barclays Premier League match between Fulham and Hull City at the KC Stadium, Hull.
16th August, 2008

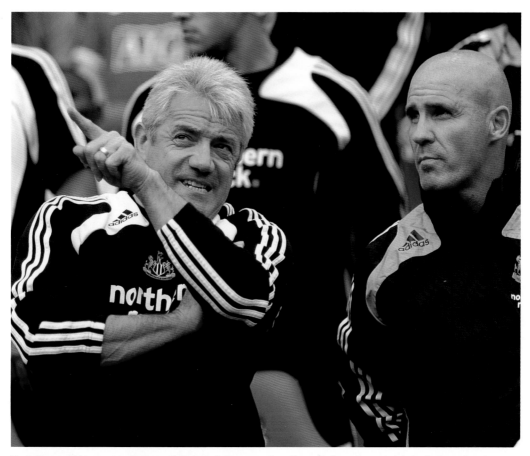

Kevin Keegan (L), manager of Newcastle United, discusses tactics with coach Steve Stone during the Barlcays Premier League match at Old Trafford between his team and home team Manchester United.
17th August, 2008

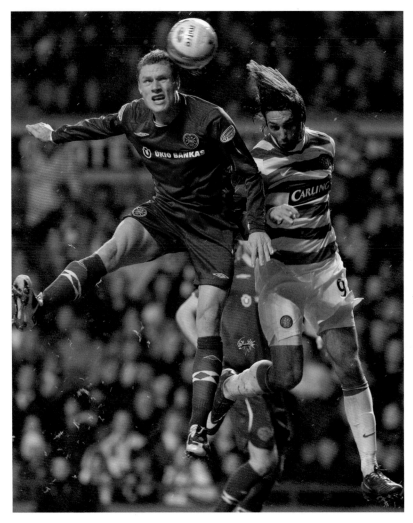

Heart of Midlothian's Marius Zaliukas (L) battles with Celtic's Georgios Samaras during the Clydesdale Bank Scottish Premier League match at Celtic Park, Glasgow. The match would end in a 1–1 draw.

13th December, 2008

Celtic's Glenn Loovens (C) leaps above Dundee's Craig McKeown (L) and Edward Malone (R) during the Homecoming Scottish Cup match at Celtic Park, Glasgow. The home team would win the game 2–1.
10th January, 2009

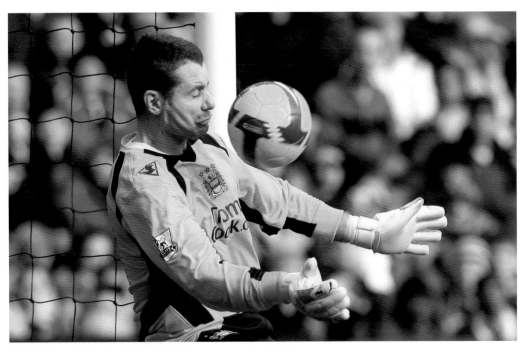

Manchester City goalkeeper Shay Given makes a save from Middlesborough's Afonso Alves during the Barclays Premier League match at the City of Manchester Stadium, Manchester. City would win the match 1–0.
7th February, 2009

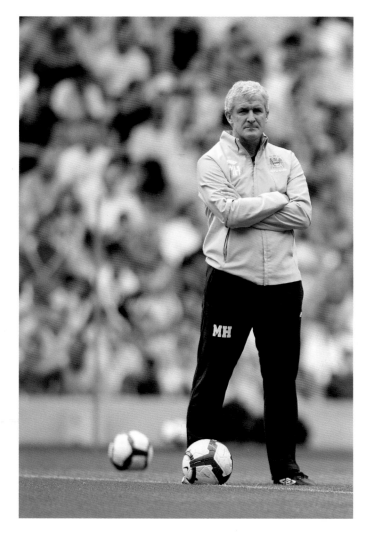

Manchester City's manager Mark Hughes during the teams' pre-season open training session at the City of Manchester Stadium.

6th August, 2009

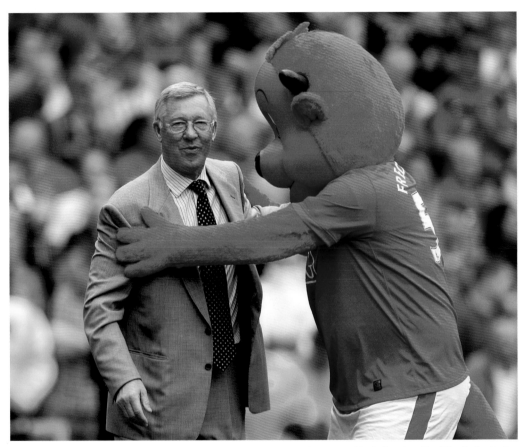

Manchester United manager Sir Alex Ferguson is greeted by the club's anthropomorphic devil mascot Fred The Red, prior to kick off in the Barlcays Premier League match United v Birmingham City at Old Trafford. Ferguson's team would win the match 1–0.

16th August, 2009

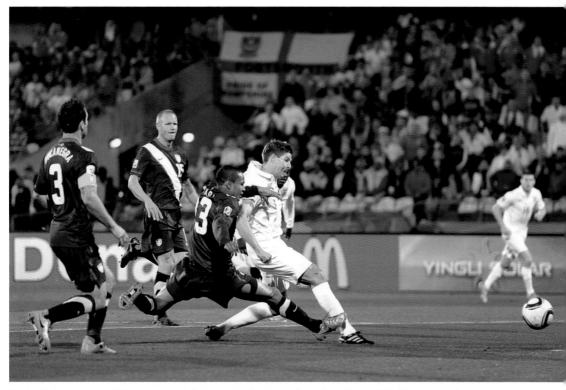

England's Steven Gerrard (C) scores his side's first goal in the Group C match against the United States team in the 2010 FIFA World Cup South Africa, held at the Royal Bafokeng Stadium, Phokeng. England had lost 1–0 against the USA in the 1950 World Cup, but on this occasion Gerrard's goal was matched by one from the US team's Clint Dempsey, resulting in a 1–1 draw.
12th June, 2010

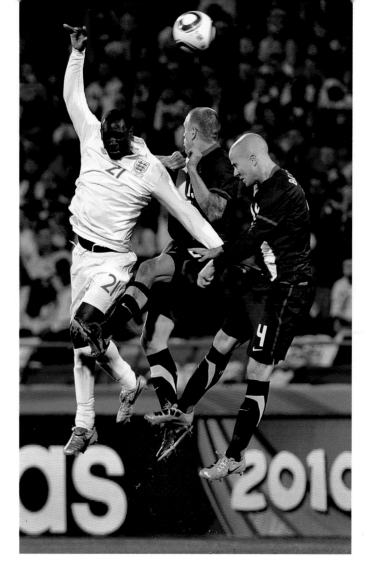

England's Emile Heskey (L) in an aerial battle for the ball with the USA's Jay DeMerit (C) and Michael Bradley, during the 2010 FIFA World Cup South Africa match at the Royal Bafokeng Stadium.
12th June, 2010

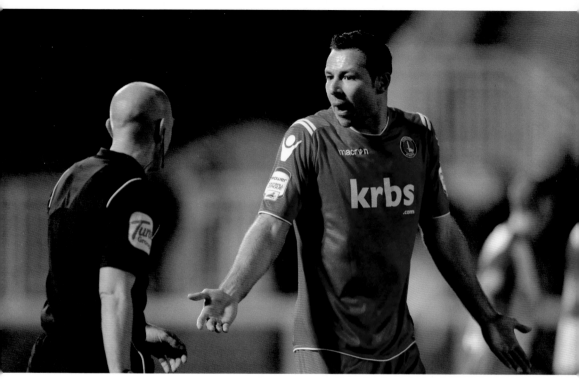

Charlton Athletic's striker Pawel Abbott (R) appeals to referee Steven Ruston in the npower Football League One match between Hartlepool United and Charlton Athletic at Victoria Park. Chris Powell suffered his first defeat as Charlton manager after four straight wins as the Addicks went down 2–1 at Hartlepool.

15th February, 2011

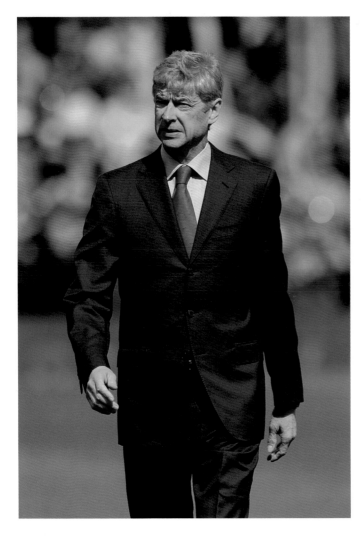

Arsenal manager Arsène Wenger before the Barclays Premier League match Fulham v Arsenal at Craven Cottage. Wenger has managed the team since 1996, and is the club's longest serving manage and the most successful, based on trophies won.
22nd May 2011

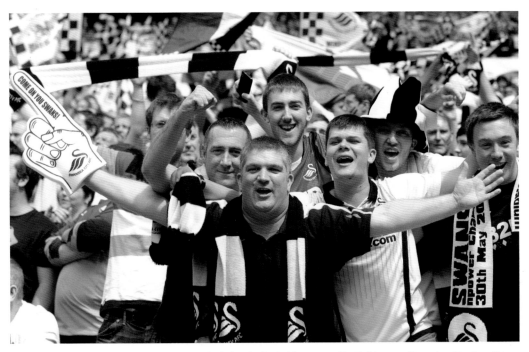

Jubilant Swansea City fans celebrate in the stands during the final of the npower Football League Championship play off between Swansea City and Reading at Wembley Stadium. The match was to decide the third team to be promoted from the Championship to the Premier League for the 2011–12 season. Scott Sinclair sealed the 4–2 win for the Swans with an 80th-minute penalty, and in doing so completing his second career hat-trick. The Swans had not played in the top flight of English football since 1983.

30 May, 2011

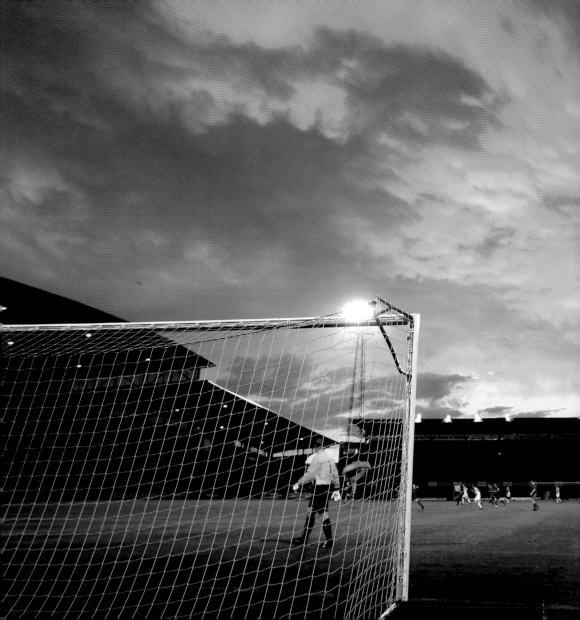

Chapter Two

PLACES

THE HALLOWED TURF

The giant stadiums are atmospheric cauldrons where dreams are realised and broken.

Part of the beauty of football is that this simple game can be enjoyed anywhere in the world, from the beaches of Rio to the playing fields of Hackney. It is the giant stadiums of the UK, though, that are held dear in fans' hearts. Their stories can be as intriguing as those of any of the players and managers.

WEMBLEY STADIUM

Originally designed to host the British Empire Exhibition, the first Wembley cost the princely sum of £750,000 and was built in less than a year. The first match was the 1923 FA Cup Final (a Bolton Wanderers 2–0 win over West Ham United). This became known as the 'White Horse Final' as the official 127,000 capacity was vastly exceeded by at least 100,000 fans and white police horses were needed to clear the pitch. The first international saw Scotland and England play out a 1–1 stalemate a year later. England's first defeat came at the hands of Scotland in 1928 when the legendary 'Wembley Wizards' ran out 5–1 victors.

Wembley has seen more than its share of pulsating FA Cup finals over the years and it was not until 1970 that it saw its first FA Cup final draw — Chelsea and Leeds were still level 2–2 after two periods of extra time failed to separate them.

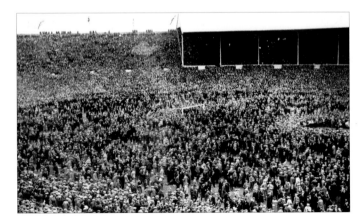

The pitch at Wembley Stadium is invaded by spectators at the first FA Cup final to be held there.
28th April, 1923

The most famous game ever played on the hallowed turf, though, was the 1966 World Cup final between England and Germany when the host nation were 4–2 winners. Ironically Germany were the last team to beat England at the 'Old Wembley' before the famous 'Twin Towers' were torn down in 2003.

Today's Wembley Stadium was opened in 2007. Its triple tiers and eight floors can seat up to 90,000 spectators, and it is regarded as one of the most impressive stadiums in the world.

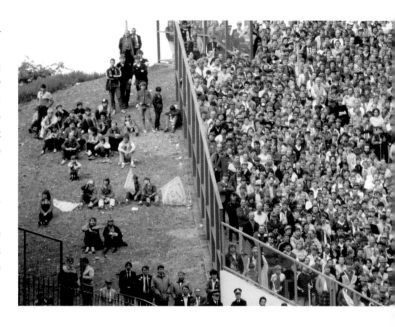

HAMPDEN

In Scotland the national stadium, Hampden, enjoys a similarly hallowed place in the national sporting psyche. The stadium opened in 1903 when the home side Queens Park recorded a 1–0 triumph over Celtic. The original capacity was colossal with the official crowd for the 1937 clash with England being 149,415 and it remained the largest stadium in the world until 1950 when it was finally usurped by the Maracanã in Brazil.

Hampden has been home to many tumultuous tussles including tempestuous 'Old Firm' finals between Glasgow rivals Rangers and Celtic. Some observers think that the best big match ever played on British soil was played here in the form of the 1960 European Cup final when 130,000 savoured Real Madrid's epic 7–3 win over Eintracht

Scotland fans watch a match through a gap in the corner of Hampden Park.
25th May, 1985

Frankfurt. The new stadium, which opened in 1999, has a seated capacity of 52,000 spread across six floors, but some diehard 'Tartan Army' fans maintain that the famous 'Hampden Roar' has been dampened by the all-seated nature of the ground and its reduced capacity.

STADIUM DISASTERS

In the pre-war years, as football became more and more popular, terraces often bulged with more fans than their designated capacity. The Burnden Park disaster in 1946, which killed 33 fans, was a warning that went largely unheeded. It took until the 1980s for radical change to be kick-started after a series of tragic incidents.

In 1971 in Glasgow, the Ibrox disaster led to the deaths of 66 fans as a stairway collapsed. In 1985 a fierce fire at the Valley Parade stadium in Bradford killed 56. Just a few weeks later came the Heysel disaster in Brussels, which killed 39 people and led to English clubs being banned from Europe. The decade came to a tragic end with the Hillsborough disaster in 1989 when overcrowding at the FA cup semi-final between Liverpool and Nottingham Forest left 96 fans dead.

NEW STADIUMS

The tragedies of the 1970s and '80s led to a dramatic rethink. The

A Manchester United fan at the front of the Old Trafford ground.
31st August, 2004

banning of alcohol and the introduction of all-seated stadiums were key changes. The 100,000-plus standing terrace crowds of Wembley and Hampden were firmly consigned to history. The Taylor Report, published in 1989, was instrumental in these changes. As crowd capacities were slashed, many clubs struggled financially to implement the changes needed to

bring their stadiums up to the new safety standards. Today, football often takes place within a huge leisure complex complete with add-ons like housing, corporate boxes, conference and incentive facilities and shops. This has become more important as clubs look to finance the huge transfer fees now involved in football.

It is Manchester United who

currently boast the largest club ground in the UK with a capacity of 76,000 at Old Trafford. The 'Theatre of Dreams' is typical of the evolution of club grounds over the last 100 years. Opened in 1910, no one in the 80,000 crowd back then could have known that the small covered seated area among the terraces was the shape of things to come.

Old Trafford was damaged by German bombing during the Second World War, but it continued to be a pioneer in the post-war decades. Today it is back to where it began, blazing a trail for the development of other club grounds as it continually strives to improve.

Some fans now bemoan the loss of the true 'spirit' of the game, but the 'experience' now offered by the new stadiums has helped bring in a wider spectrum of supporters with more families and children attending. Take the 74,500 capacity Millennium Stadium in Cardiff: it may not have standing terraces, but no one doubts the atmosphere that it can generate. Few doubt that today's stadiums are safer than ever before.

The rebuilt Wembley Stadium.
21st November, 2007

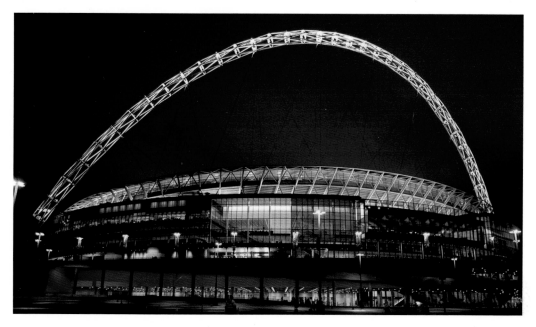

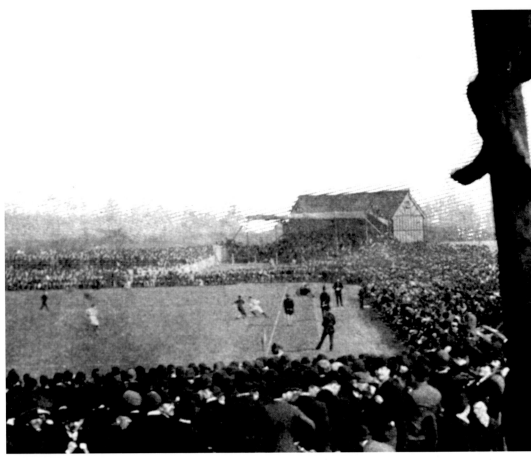

A general view of the action from the back of the crowd, one of whom has climbed a telegraph pole for a better view, at the 1893 FA Cup Final between Wolverhampton Wanderers and Everton. The location is the Fallowfield Ground, Manchester.
25th March, 1893

A view of the pitch from the perspective of one of the 45,000 crowd assembled at the Fallowfield Ground, Manchester, for the 1893 FA Cup Final between Wolves and Everton. The result was a 1–0 victory for Wolves.

25th March, 1893

A general view of the FA Cup Final between Aston Villa and Everton, played at the Crystal Palace before a crowd of over 65,000. Villa clinched a 3–2 victory over the Toffees.

10th April, 1897

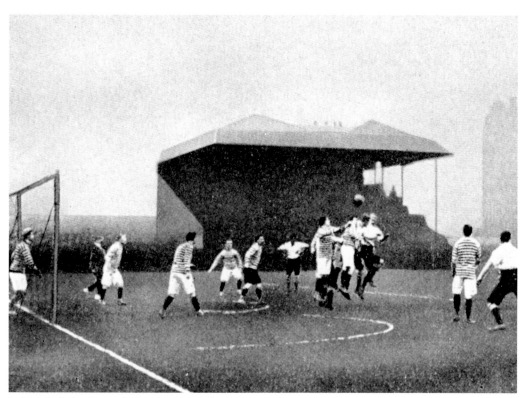

Aerial action in the Queens Park goalmouth at a friendly between Queens Park and Corinthians in 1901.
12th March, 1901

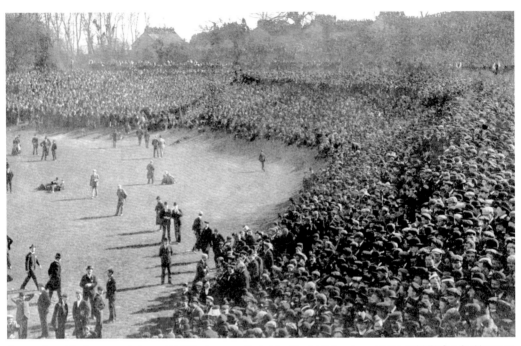

An overview of the huge crowd of over 114,000 who assembled at the Crystal Palace to watch the 1901 FA Cup final between Tottenham Hotspur and Sheffield United.
20th April, 1901

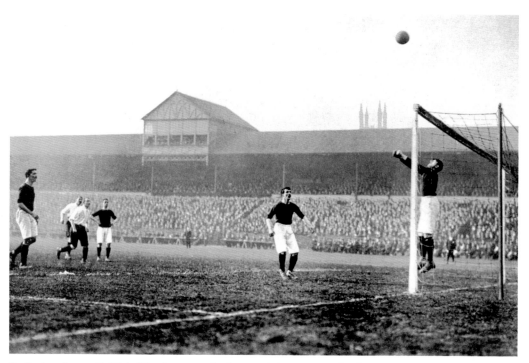

Scotland goalkeeper Ned Doig (R) makes an unorthodox save during a game against England at Sheffield in 1903.
4th April, 1903

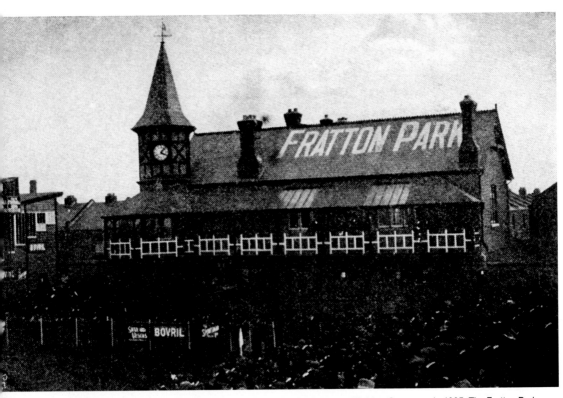

The Portsmouth home crowd take to their seats before a Southern League Division One game in 1905. The Fratton Park pavilion in the corner proudly displays the name of the ground for all to see.
30th September, 1905

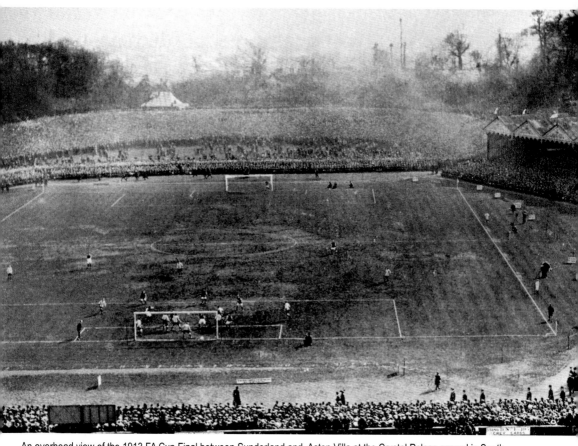

An overhead view of the 1913 FA Cup Final between Sunderland and Aston Villa at the Crystal Palace ground in South London. The result was a 1–0 victory for Aston Villa.

19th April, 1913

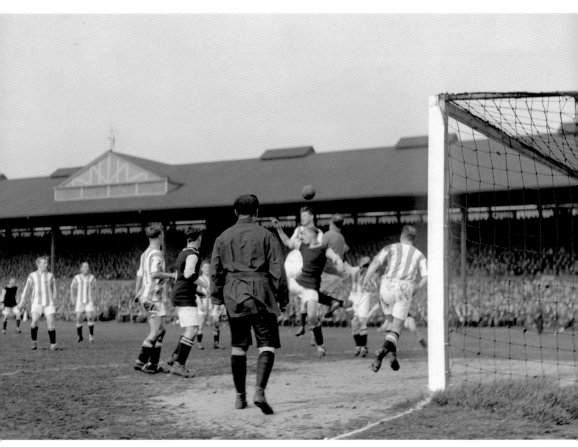

Footballing action in the Huddersfield Town goalmouth during the 1920 FA Cup Final between Aston Villa and Huddersfield Town at Stamford Bridge. It was a 1–0 victory for Villa.

24th April, 1920

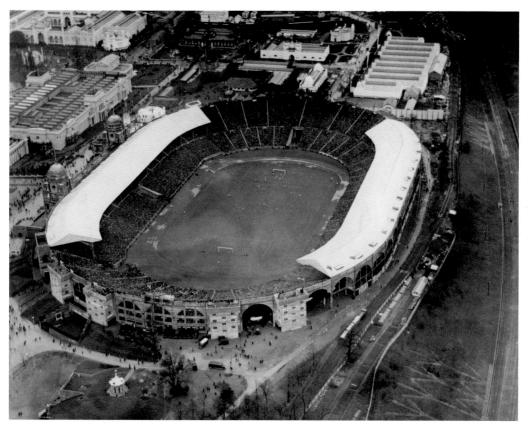

An aerial view of Wembley Stadium during the 1927 FA Cup Final between Cardiff City and Arsenal, which ended in a 1–0 win for the Welsh team.
23rd April, 1927

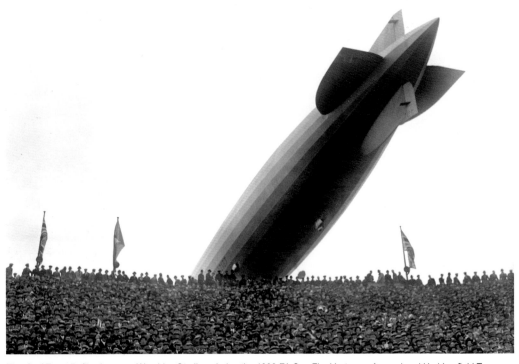

The *Graf Zeppelin* flies low over Wembley Stadium during the 1930 FA Cup Final between Arsenal and Huddersfield Town. The North London team secured a 2–0 victory over the West Yorkshire visitors.
26th April, 1930

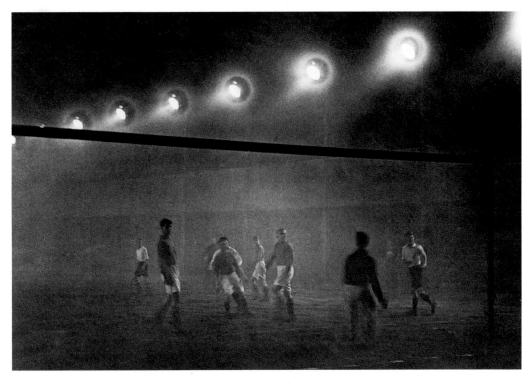

To test the possibilities of floodlit football, a try-out match was convened at the Arsenal practice ground in 1932, which had been specially wired for floodlighting.
28th November, 1932

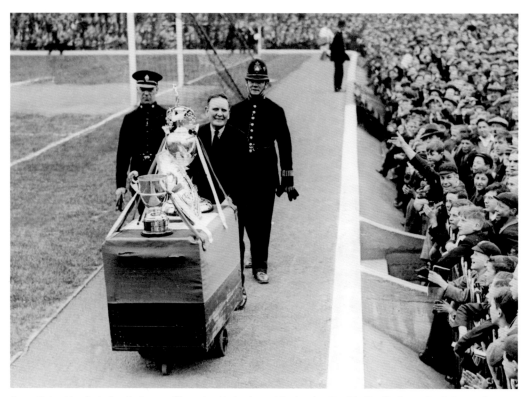

Arsenal's trophies (including the League Championship trophy and the London Combination Cup) are wheeled around Highbury in 1934 for the fans to view at close quarters.
1st December, 1934

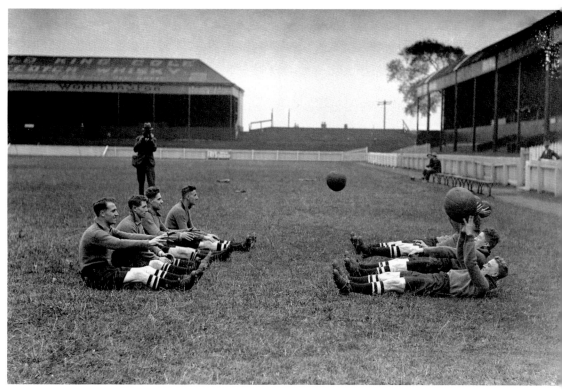

Notts County players throw medicine balls to each other during training at the club's ground in 1935.
18th August, 1935

At a 1936 FA Cup game between Chelsea and Plymouth Argyle at Stamford Bridge, a section of the 53,703 strong crowd hold a two-minute silence in honour of King George V, who died five days before this match.
25th January, 1936

Spectators arriving at Wembley Stadium at a wartime international match between England and Scotland.
4th October, 1941

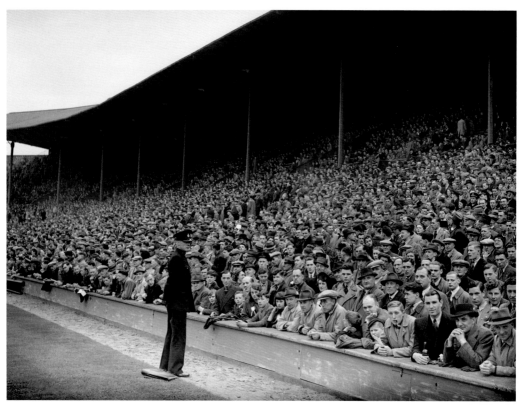

A general view of the crowd at Wembley Stadium at the Football League Cup (South) Final between Arsenal and Charlton Athletic. It was huge win for Arsenal over their London rivals, beating Charlton 7–1.
1st May, 1943

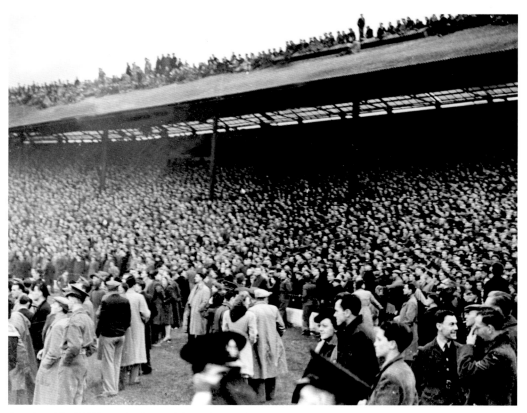

A section of the 85,000 crowd spills out of the packed stands onto the pitch as several hundred daring souls, desperate to see the lauded Dynamo Moscow team during their tour of Britain, get an elevated, if somewhat dangerous, view from the roof of the stand. The Russian team played against Chelsea at Stamford Bridge, resulting in a 3–3 draw.

13th November, 1945

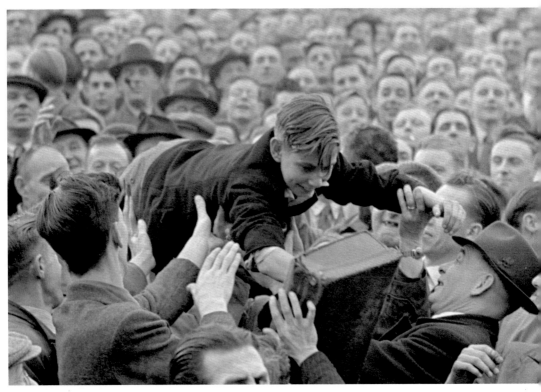

A young fan is passed over the heads of the crowd to a better viewing position at the front of the terrace at Stamford Bridge, as Chelsea take on Arsenal in a First Division clash.
1st November, 1947

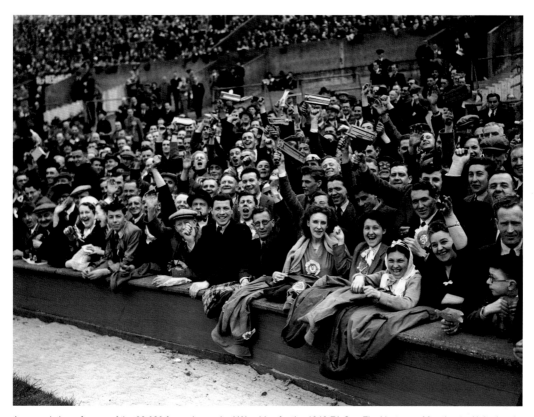

A general view of some of the 98,920 fans who packed Wembley for the 1948 FA Cup Final between Manchester United and Blackpool. It was a 4–2 victory for Manchester's Red Devils.
24th April, 1948

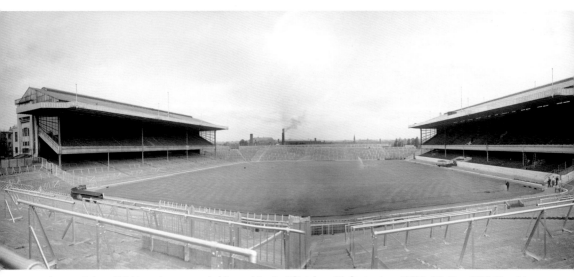

A general view of Highbury, homeground of Arsenal Football Club from 6th September, 1913 to 7th May, 2006. The club moved to the new, larger Emirates Stadium nearby in 2006.

7th October, 1949

A policeman talks to a colleague on his new walkie-talkie telephone at an FA Cup Sixth Round game between Arsenal and Leeds United.
4th March, 1950

Chelsea players warm up for a training session at Stamford Bridge in preparation for their next First Division fixture.
21st July, 1950

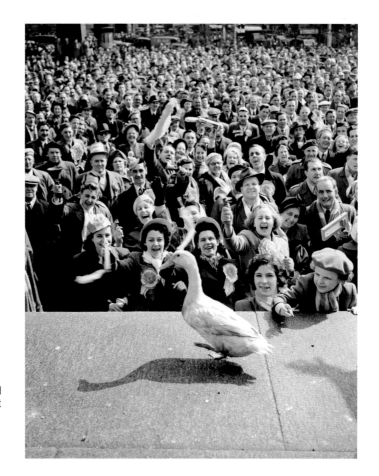

Blackpool fans and a feathered friend before the 1951 FA Cup Final against Newcastle United at Wembley Stadium. The final result was a 2–0 win for Newcastle.

28th April, 1951

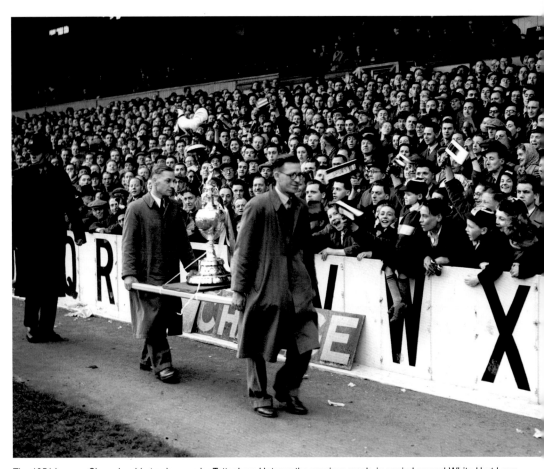

The 1951 League Championship trophy, won by Tottenham Hotspur the previous week, is carried around White Hart Lane before a Division One match against Liverpool.

5th May, 1951

A general view of an informal football match in progress between the Rams and the Gates in the 1952 Ramsgate Regatta Trophy on Goodwin Sands, Ramsgate.
21st July, 1952

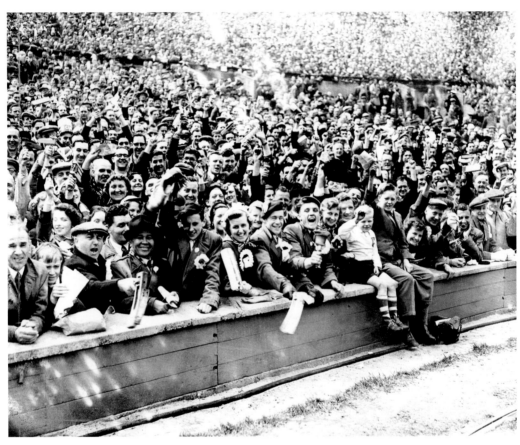

Enthusiastic Preston North End fans, equipped with bells and rattles, wait for the kick-off in the 1954 FA Cup Final against West Bromwich Albion at Wembley. Despite the fans' support, Albion defeated Preston in a 3–2 win.
1st May, 1954

Arsenal's 'boot-room boy' Danny Cripps examines star striker Tommy Lawton's boots at Highbury.
3rd February, 1955

L–R: Jim Fotheringham, Dave Bowen and Derek Tapscott working out in Arsenal's Highbury gymnasium.
3rd February, 1955

The scene during the first game at Wembley to be played under floodlights. The 1955 game was an Inter Cities Fairs Cup between London and Frankfurt. London won the match 3–2, despite being 2–0 down at half-time.
26th October, 1955

Bournemouth and Boscombe Athletic fans show their support before an FA Cup Sixth Round clash against Manchester United.
2nd March, 1957

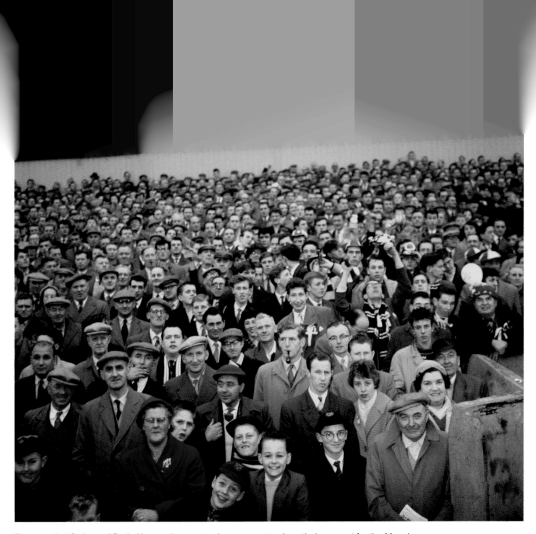

The crowd at St James' Park, Newcastle, captured on camera to show their support for the Magpies.
1st January, 1960

Arsenal's new signing George Eastham admires Highbury's marble entrance hall. The inside-forward and midfielder made 207 League appearances for the club between 1960 and 1966.

18th November, 1960

Arsenal physiotherapist Bertie Mee using revolutionary new techniques to treat an injured patient.
14th April, 1961

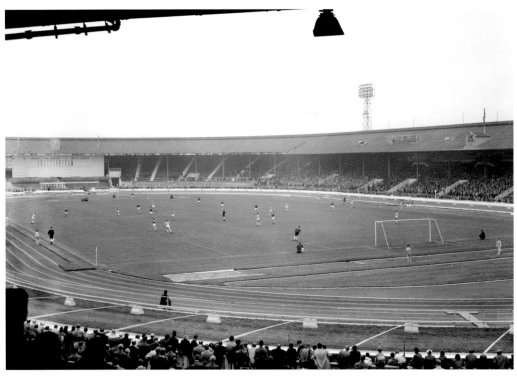

A general view of the White City, home of Queens Park Rangers, during a 1962 Division Three match against Notts County. Originally built for the 1908 Summer Olympics, QPR played at White City from 1931 to 1933 and again in 1962–63, but eventually made Loftus Road their permanent home. The stadium was demolished in 1985.

6th October, 1962

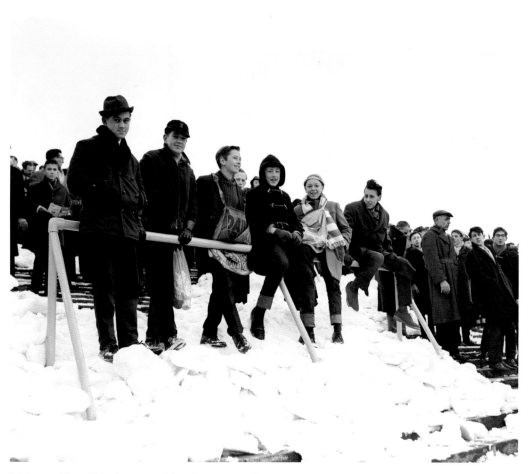

Brighton and Hove Albion fans get a slightly elevated view of a match by standing on slabs of frozen snow on the terraces. This picture was taken during a Division Three clash with Crystal Palace during the freezing winter of 1963.

12th January, 1963

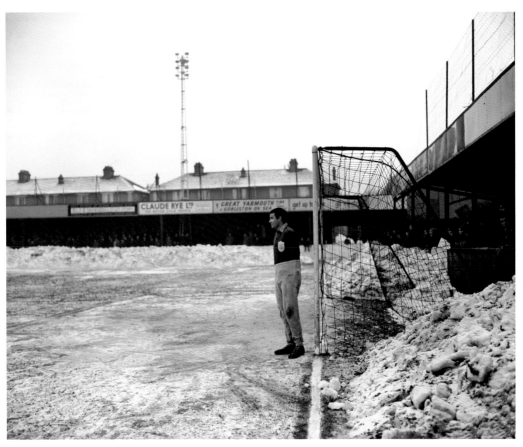

Walthamstow Avenue goalkeeper G. McGuire keeps warm in the Big Freeze of 1963 by thrusting his hands down his tracksuit trousers. This candid picture was taken during an FA Amateur Cup game against Grays Athletic.

12th January, 1963

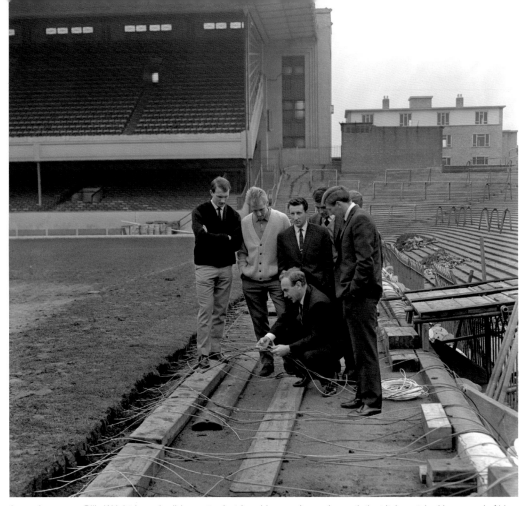

Arsenal manager Billy Wright (crouched) inspects electric cables running underneath the pitch, watched by several of his players. The cables supply power to Highbury's new undersoil heating system.
24th April, 1964

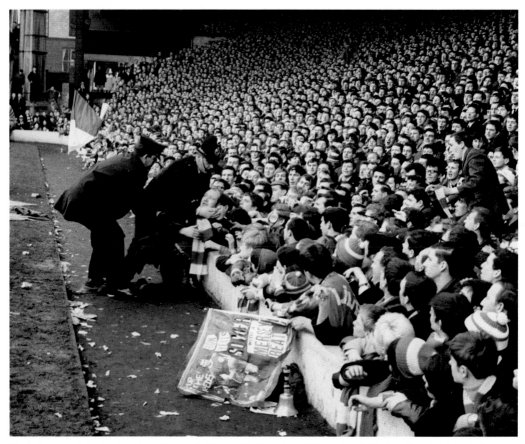

The police move in to stop trouble on Liverpool's Kop, on 5th November, 1966 against Nottingham Forest. A 4–0 win for the Reds.

5th November, 1966

A winter's day at Molyneux, home of Wolverhampton Wanderers. This picture was taken at a Division Two fixture between Wolves and Coventry City. The visitors clinched a 1–0 victory over Wolves.
3rd December, 1966

Birmingham City employees George Moore (L) and Tommy Bell paste up a poster advertising the forthcoming fixtures taking place at St Andrews.
9th February, 1968

Facing page: New Chelsea manager Dave Sexton (L) stands on the Stamford Bridge terraces with Chairman Charles Pratt. Sexton managed the club from 1967 to 1974. He led the club to an FA Cup victory in 1970 and success in the European Cup Winners' Cup in 1971.
23rd October, 1967

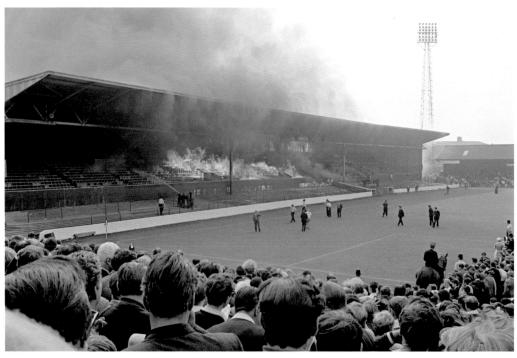

The evacuated crowd watches from the pitch as the Main Stand of Nottingham Forest's City Ground burns down during a Division One game against Leeds United. The fire probably started in the dressing room area, and many of the club's records and trophies were lost. The stand was rebuilt with a capacity of 5,708.

24th August, 1968

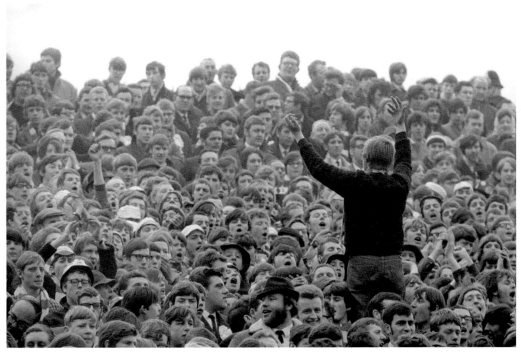

A West Bromwich Albion fan encourages his fellow supporters to sing up in support of their team at the 1969 FA Cup Semi Final between West Bromwich Albion and Leicester City. Leicester defeated Albion 1–0, but Manchester United were victorious in the Final, beating Leicester 2–1.

29th March, 1969

Peel Park, the abandoned home of former Football League club Accrington Stanley. The original club – one ot the 12 founders of the Football League in 1888 – went into liquidation in 1966 after many years of decline. The club was revived in 1970 and it moved to a new home at the Crown Ground.
1st July, 1969

A policeman encourages a young Blackpool fan back into the crowd as a goal causes mass delirium among the home supporters. The action took place at a Division One fixture against West Bromwich Albion at Bloomfield Road. The goal was not enough to win the game – the final result was Blackpool 3, Albion 1.
22nd August, 1970

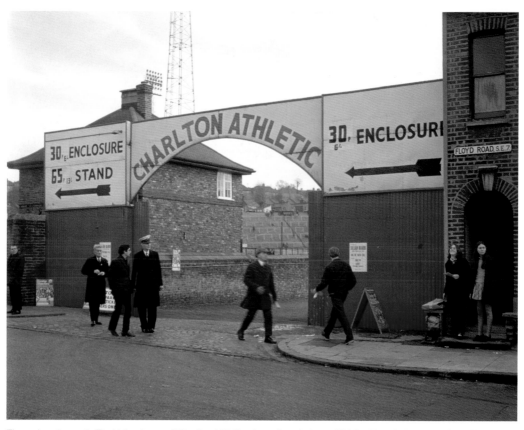

The main entrance to The Valley, home of Charlton Athletic, shown here before a Division Two clash against Cardiff City. The Valley has been home to the club since 1919, apart from one year in Catford (1923–24) and seven years at Crystal Palace and West Ham United between 1985 and 1992.

21st November, 1970

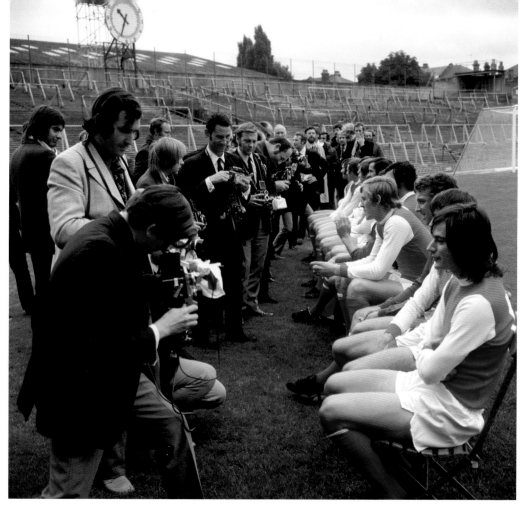

Arsenal players face the cameras as a prelude to the 1971–72 soccer season. During this season Arsenal defended the previous season's successes in the League Championship and FA Cup. They were unsuccessful – Stoke City won the League and Leeds cllinched the FA Cup.

13th August, 1971

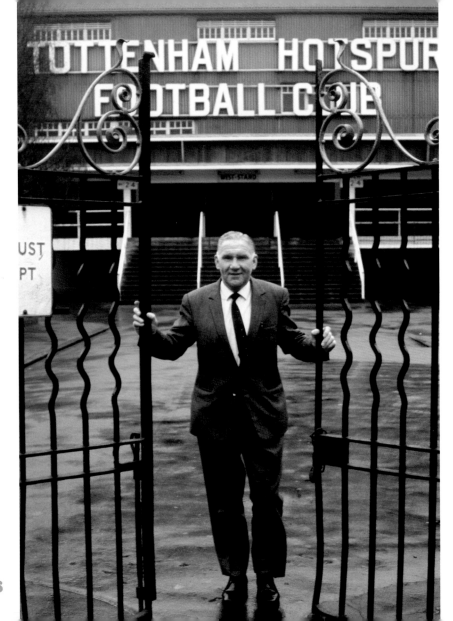

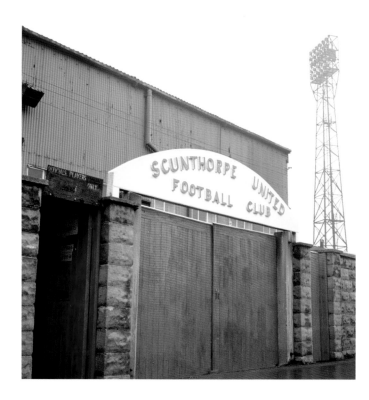

The main entrance to The Old Showground, home of Division Four Team Scunthorpe United. Built in around 1867, Scunthorpe United played at the ground until 1988, when they moved to the newly constructed Glanford Park Stadium.
1st October, 1975

Facing page: Bill Nicholson, manager of Tottenham Hotspur. Nicholson took over as manager in 1958. He resigned in August 1974, shortly after Spurs lost the UEFA Cup final to Feyenoord.
1st January, 1974

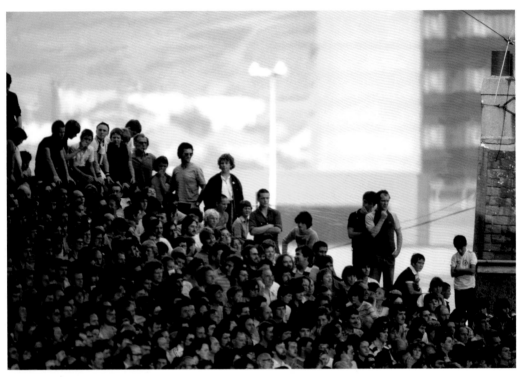

Fans at the Vetch, home of Swansea City, in 1981. The Vetch was a multi-purpose stadium that opened in 1912. It was the residence of Swansea City up until 2005, when the club relocated to the new Liberty Stadium.
29th August, 1981

Half-empty terraces at the Clock End of Highbury, home of Arsenal, during a Division One clash between the Gunners and Birmingham City. The result was a 0–0 draw.

30th October, 1982

Workmen begin laying the new grass pitch at Queens Park Rangers' Loftus Road after the artificial pitch was torn up. The so-called 'plastic pitch' was laid down in 1981, but proved unpopular with fans and players alike.
10th June, 1988

Fans in the stand at the City Ground, prior to the match being abandoned due to heavy snowfall during the FA Cup Fifth Round game between Nottingham Forest and Tottenham Hotspur.

19th February, 1996

The St George's Cross flag flies against a vivid sunset at Wembley Stadium at a 1996 friendly between England and Croatia. The game was less dramatic, with a 0–0 final score.
24th April, 1996

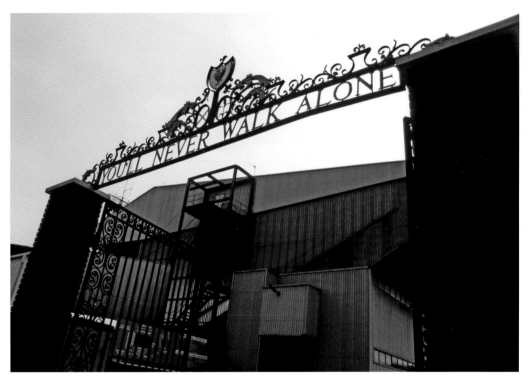

The Shankly Gates at Anfield, home of Liverpool. Erected in 1982 as a tribute to revered former manager Bill Shankly, the gates were unlocked by Shankly's widow Nessie for the first time on 26th August, 1982.
10th July, 1997

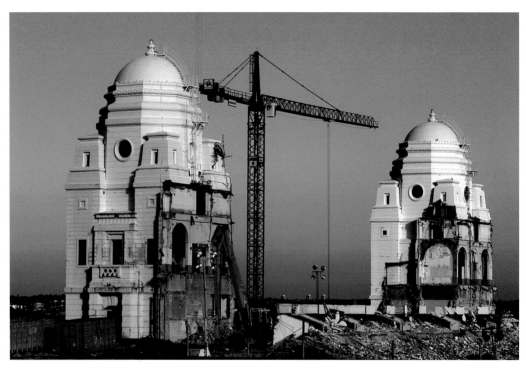

A crane looms between the twin towers of the old Wembley Stadium in north west London as this famous landmark is demolished to make way for a brand new building. Demolition work had begun in December 2002. The top of one of the towers was to be erected as a memorial in the park on the north side of Overton Close in the Saint Raphael's Estate.
6th February, 2003

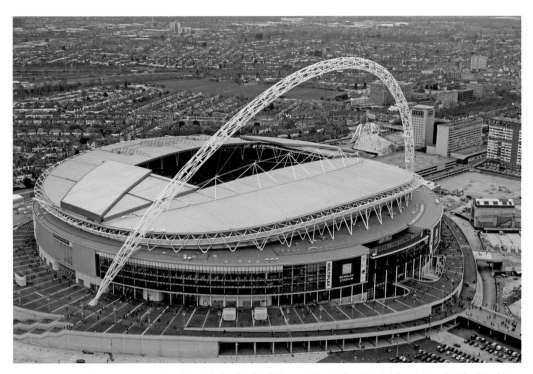

The new Wembley Stadium viewed from the air during the Geoff Thomas Foundation Charity VI match against the Wembley Sponsors Allstars, which was the venue's first event. Local residents and England suppoters were allowed into the new ground for a 'community day' staged as part of the procedure to get the general safety certificate.
17 March, 2007

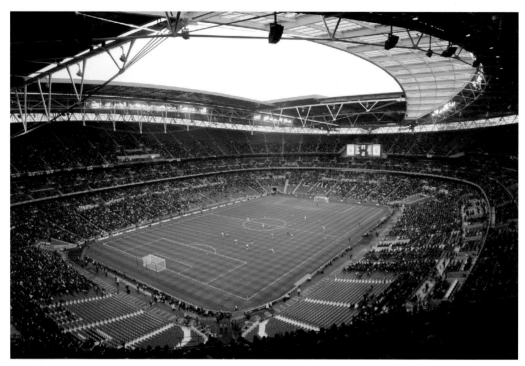

A general view of Wembley Stadium at the beginning of the England v Italy under 21 international football friendly. Tens of thousands of England fans received their first taste of the new £800m Wembley during the first official fixture at the ground. Some 60,000 seats were filled with England supporters, as the national under-21s side took on Italy in a world record attendance for an under-21s game.

24 March, 2007

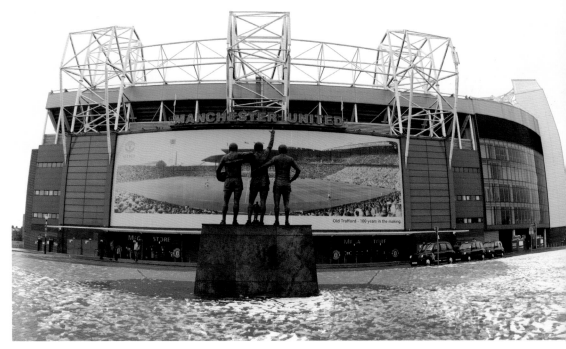

The United Trinity statue of Best, Law and Charlton faces a poster on the East Stand of Manchester United's stadium showing a montage of an old and new version of the ground at Old Trafford, Manchester.
24 March, 2007

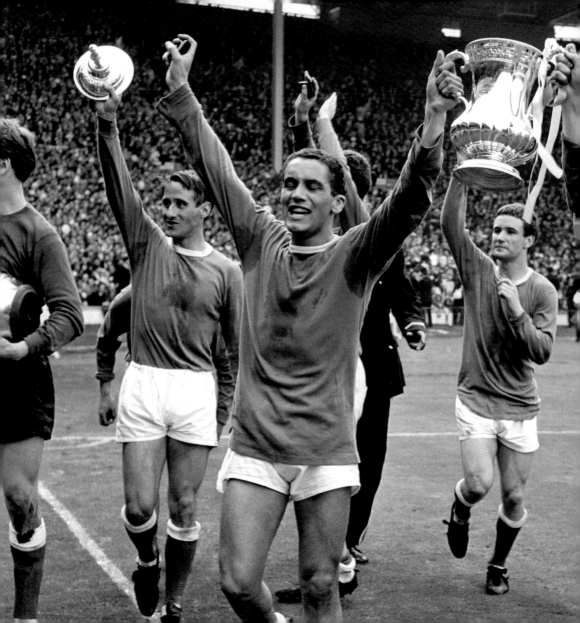

Chapter Three

MOMENTS

HIGHS & LOWS

It's meant to be the taking part and not the winning that counts, but few football fans would agree.

For the serious football supporter, winning the match counts for everything and the disasters that occur on the pitch are as painfully felt as the triumphs are rapturously celebrated.

UPSETS

Every fan has his or her own personal upset, whether it is David Beckham's sending off and the subsequent defeat to Argentina during the World Cup in 1998, Scotland losing to a soft late goal by Brazil in the opening game of the same tournament, or Wales narrowly losing out in the race to qualify for the 1986 World Cup.

England may have famously beaten Germany in 1966, but it took until Euro 2000 for them to repeat this in a competitive match. In between there were painful defeats for England at both the 1970 and 1990 World Cup finals and at Wembley during Euro 96.

Scotland qualified for five World Cups in a row from 1974 through to 1990, but failed to make it to the group stages in any of them. Bad defeats and poor draws are ingrained on the fans' memories along with the painful knowledge that they were only denied qualification on goal difference in three of the five tournaments.

England's Steven Gerrard sits dejected after the final whistle, as Croatia players celebrate victory in the Euro 2008 qualifying match. Defeat meant England failed to qualify.
21st November, 2007

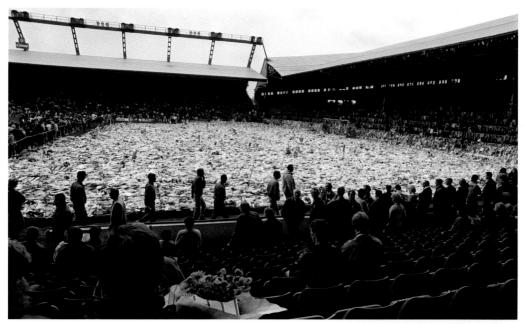

DEFEATS

Perhaps the ultimate defeat is vying for the league title all season long, only to fall on the final day of the season. This bitter fate has befallen a number of teams, with Liverpool memorably losing the title to the last kick of the season when Michael Thomas scored Arsenal's decisive second goal at Anfield in 1989. In Scotland, Celtic suffered the same fate twice in three years: in 2003, when Rangers pipped them by a single goal, and in 2005 when two very late goals from Motherwell striker Scott McDonald meant that Rangers won the title.

TRAGEDIES

A string of tragedies have afflicted the game over the last century, bringing terrible losses to families

Thousands of fans, friends and family gathering at Anfield stadium around a pitch full of flowers for the ceremony of remembrance for all those who died in the tragic Hillsborough disaster.
22nd April, 1989

and tarnishing football's good name. The stadium disasters from the 1970s through to the late 1980s still haunt the game today. One of British football's most tragic days was 6th February, 1958 when many of the 'Busby Babes' were killed in the Munich Air Disaster. These darker moments in football are never forgotten by the fans, with commemorations of their anniversaries still an essential and deeply ingrained part of club culture today.

TRIUMPHS

England's 1966 World Cup win still delights England fans as does Gascoigne's wonder strike to finish off Scotland at Euro 96. For Scottish fans, there is the 3–2 win in 1967 over England and Archie Gemmill's famous dribble and wonder goal in the dramatic 3–2 win over Holland in the 1978 World Cup. Wales fans

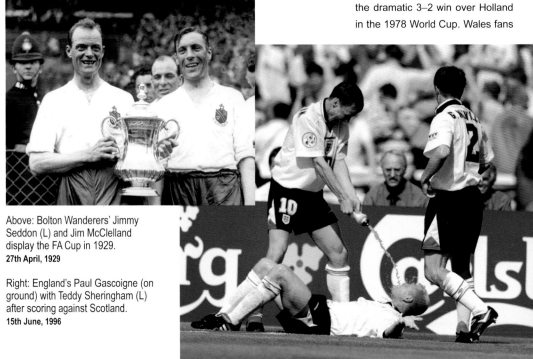

Above: Bolton Wanderers' Jimmy Seddon (L) and Jim McClelland display the FA Cup in 1929.
27th April, 1929

Right: England's Paul Gascoigne (on ground) with Teddy Sheringham (L) after scoring against Scotland.
15th June, 1996

can think fondly of the 1958 World Cup and their unbeaten run to the knockout stages.

Recent club triumphs that stand out in England include Manchester United's stunning late comeback in the Champions League final against Bayern Munich in 1999, when they fought back from 1–0 down in the dying seconds to score twice and lift the trophy for the first time since 1968. Then there was Liverpool's dramatic comeback in the Champions League final of 2005. They were down 3–0 to AC Milan at half-time, but a trio of goals in a six minute spell turned the game on its head and Liverpool ran out winners after a nailbiting penalty shoot-out.

On the domestic front winning the league is unquestionably the big one, as it tends to reward the best performance across the whole season. The honour of winning the old Division One/new Premier League has gone to a total of 23 clubs since the first championship title was awarded to Preston North End in 1889.

The English FA Cup is the perfect forum for triumphs when so much can change in an instant. Great minnow performances include Brighton & Hove Albion making it to the FA Cup Final in 1983 and coming within a whisker of upstaging Manchester United before losing in a replay. Wimbledon went one better in 1988, beating Liverpool 1–0.

North of the border, both Celtic and Rangers boast a long list of domestic triumphs. Celtic between 1966 and 1974 won a staggering nine titles in a row, while Rangers equalled the feat between 1989 and 1997. Other Scottish clubs, of course, have won the top division, and there was also the Cup Winners' Cup final 2–1 triumph over Real Madrid for Aberdeen in 1983, and Dundee United's impressive runs to the European Cup semi-final in 1984 and the UEFA Cup final in 1987.

Scotland's Denis Law (R) is congratulated by an ecstatic fan. **15th April, 1967**

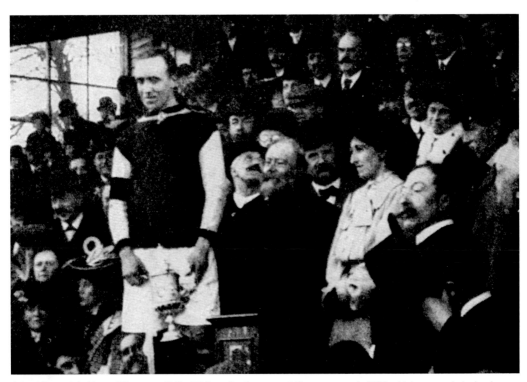

Aston Villa captain Howard Spencer with the FA Cup after the presentation ceremony in 1905, which was made by Lord Kinnaird (C, with beard). Villa had beaten Newcastle United 2–0 in the Final.
15th April, 1905

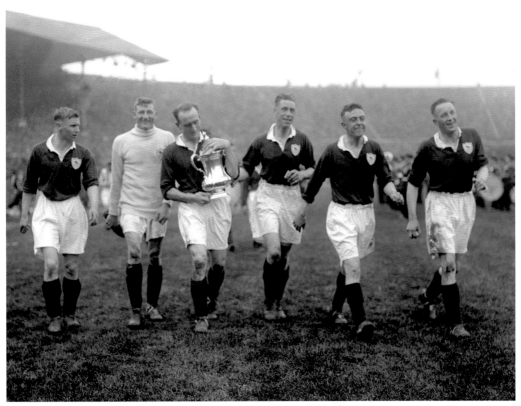

Arsenal captain Tom Parker (third L) keeps a tight grip on the FA Cup as he and his teammates parade the trophy around Wembley in 1930, L–R: Cliff Bastin, Charlie Preedy, Tom Parker, Bill Seedon, Joe Hulme, Jack Lambert. The team defeated Huddersfield Town in a 2–0 victory at Wembley Stadium.

26th April, 1930

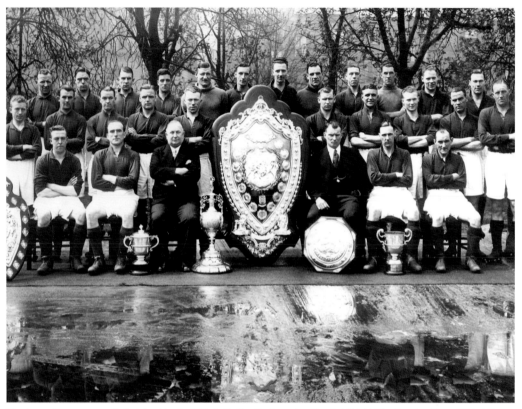

The Arsenal team group with their trophies in 1931. L–R: The Northampton Hospital Shield, The Evening News Cricket Cup, The League Championship trophy, The Sheriff of London's Shield, The Charity Shield and The Combination Cup.
23rd April, 1931

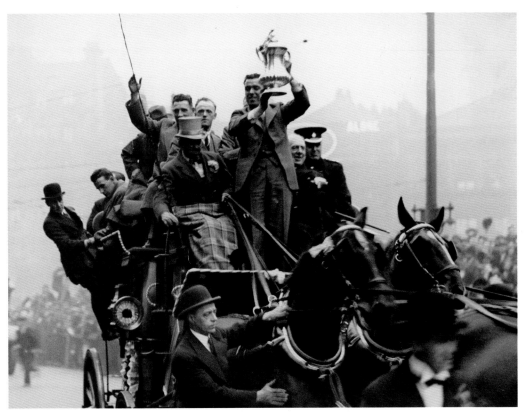

Everton's Bill 'Dixie' Dean holds up the FA Cup as the team emerge onto Lime Street, Liverpool. The 1933 FA Cup Final was contested by Everton and Manchester City. The Toffees won 3–0, with Dean supplying one of the goals.
1st May, 1933

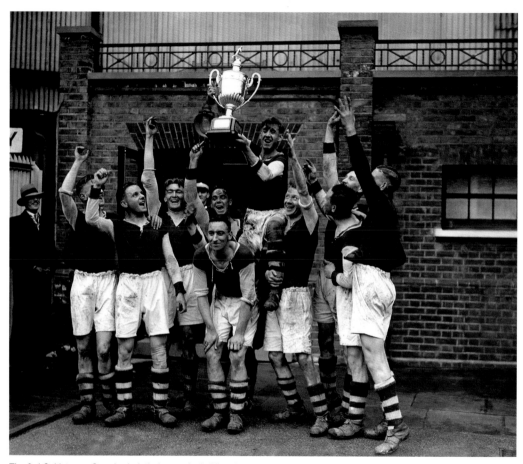

The 3rd Coldstream Guards chair their captain, holding the cup, as they celebrate their 2–1 victory over the Guards Depot in the Household Brigade Senior Cup final.
2nd April, 1935

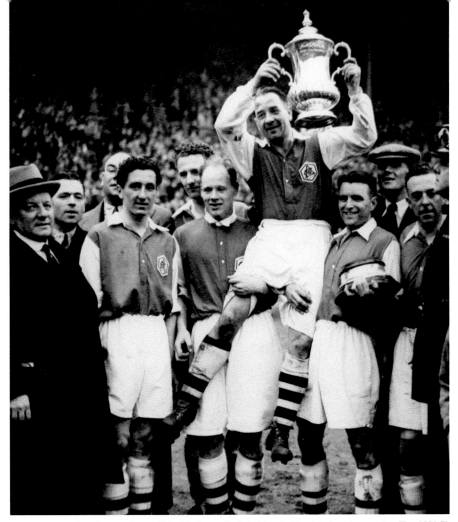

Arsenal captain Alex James shows off the FA Cup as he is held up by his victorious teammates. The 1938 Final was contested against Sheffield United. The Gunners defeated their opponents 1–0.
25th April, 1936

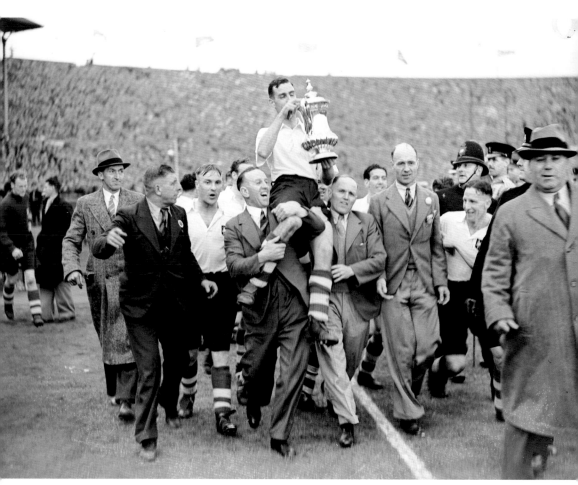

The winning captain, Preston North End's Tom Smith, shows off the FA Cup as he is chaired around the pitch in 1938. The team took on Huddersfield Town and won with a penalty in extra time.
30th April, 1938

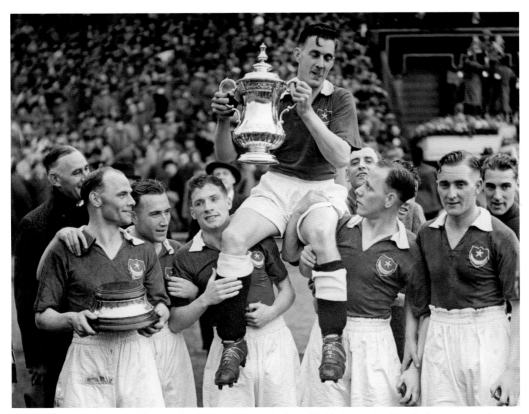

Portsmouth captain Jimmy Guthrie holds the FA Cup aloft as he is chaired by his teammates. The Final was a resounding victory for Portsmouth, securing their win in a 4–1 triumph over Wolverhampton Wanderers.
29th April, 1939

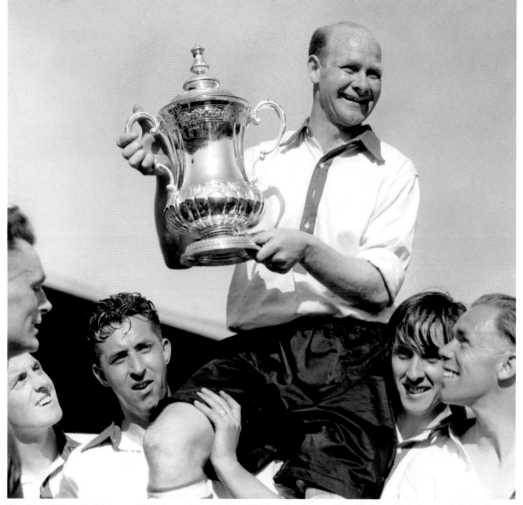

Charlton Athletic's Bert Johnson (R) looks up at captain Don Welsh as he shows off the FA Cup while being carried shoulder high by triumphant teammates Jack Shreeve (second L) and Peter Croker (second R) in 1947.
26th April, 1947

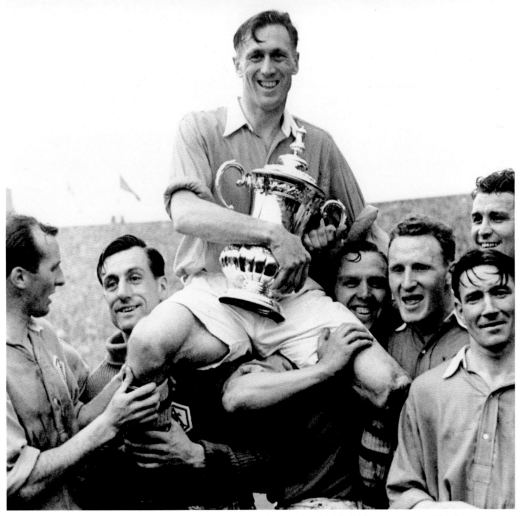

Arsenal captain Joe Mercer clings on to the FA Cup as he is carried shoulder high by jubilant teammates. The Gunners won the trophy in a 2–0 triumph over Liverpool at Wembley.
29th April, 1950

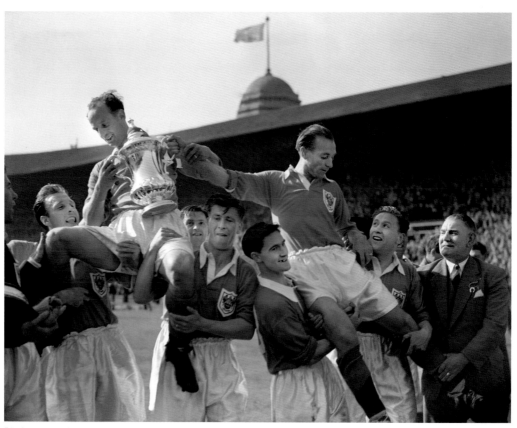

Blackpool captain Harry Johnston (top L) holds the FA Cup after his team came back from 3–1 down to win 4–3 against Bolton Wanderers, thanks to inspired performances from Stanley Matthews (top R), hat-trick hero Stan Mortensen (second R) and winning goal-scorer Bill Perry (third L).
2nd May, 1953

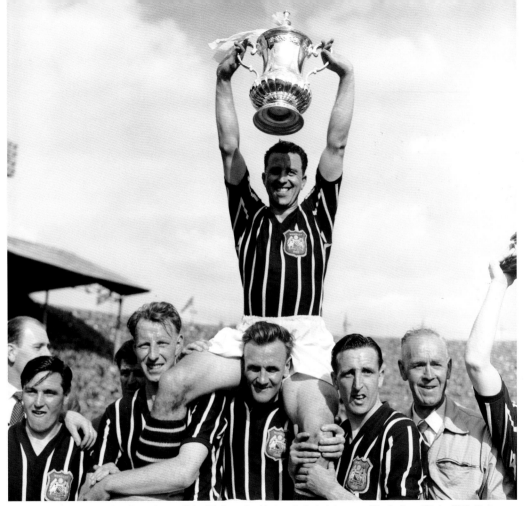

Manchester City captain Roy Paul shows off the FA Cup after his team's 3–1 victory over Birmingham City in 1956. He is supported by teammates (L–R) Bobby Johnstone, Dave Ewing, Don Revie and Ken Barnes.
5th May, 1956

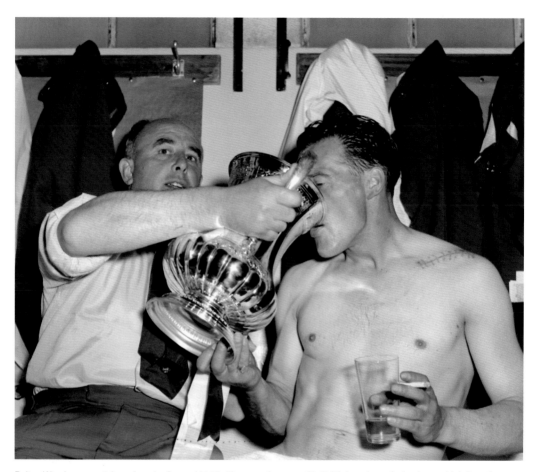

Bolton Wanderers captain and centre-forward Nat Lofthouse, who scored both his team's goals, is given a drink from the FA Cup by manager Bill Ridding in the dressing room at Wembley, after Bolton defeated Manchester United 2–0 in the 1958 Final.

3rd May, 1958

Tottenham Hotspur captain Danny
Blanchflower poses with the FA Cup.
Spurs clinched the title with a 3–1 win
in the Final against Burnley.
3rd August, 1962

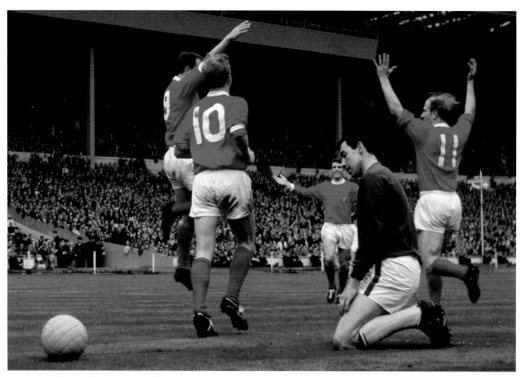

In the 1963 FA Cup Final, Leicester City goalkeeper Gordon Banks looks down dejectedly as Manchester United's David Herd (L) celebrates scoring with teammates Denis Law (second L), Johnny Giles (third L) and Bobby Charlton (R).
25th May, 1963

Facing page: Manchester United's Noel Cantwell (C) throws the FA Cup into the air, watched by astonished teammates (L–R) Tony Dunne, Bobby Charlton, Pat Crerand, Albert Quixall and David Herd. The Red Devils defeated Leicester City 3–1.
25th May, 1963

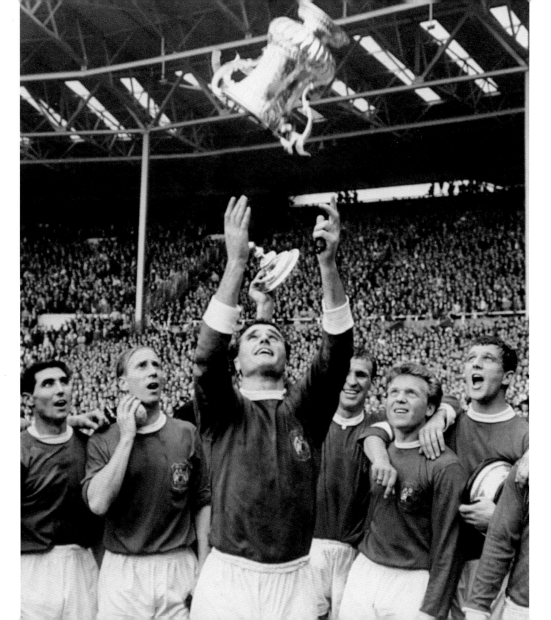

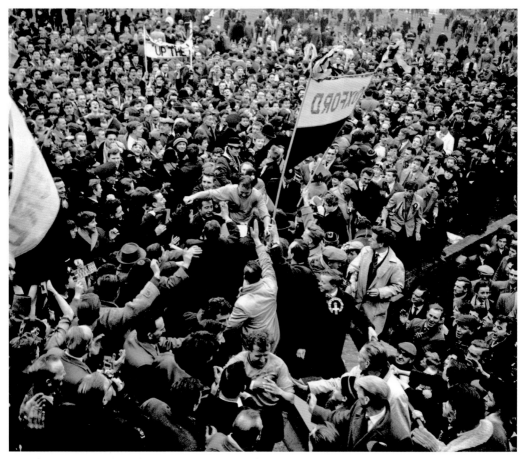

Oxford United captain Ron Atkinson (C) is carried off by euphoric fans after his team beat First Division Blackburn Rovers 3–1 in the Fifth Round of the FA Cup.

15th February, 1964

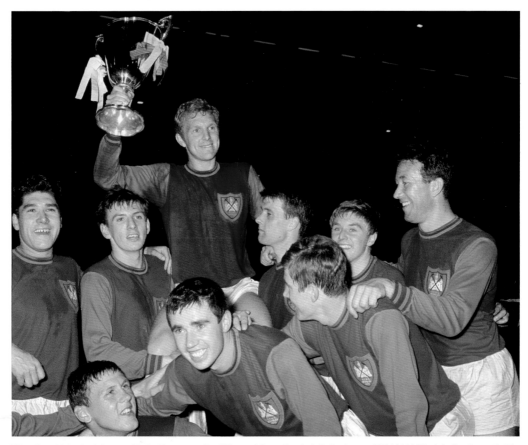

West Ham United celebrate with the European Cup Winners' Cup after their 2–0 win over TSV 1860 Munich: (back row, L–R) Alan Sealey, Martin Peters, Bobby Moore (with cup), Geoff Hurst, John Sissons, Ken Brown; (front row, L–R) Brian Dear, Ronnie Boyce, Jack Burkett.
19th May, 1965

England manager Alf Ramsey (second R) explains his ideas to England players (L–R) Gordon Banks, George Cohen, Jack Charlton, Peter Thompson, Jimmy Greaves, Bobby Tambling, Bobby Charlton, as coach Harold Shepherdson (R) looks on.
1st June, 1966

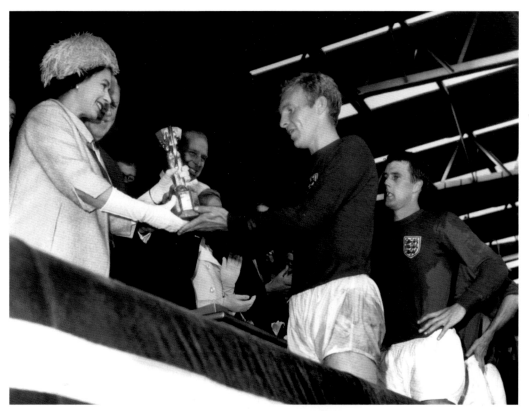

England captain Bobby Moore is presented with the Jules Rimet trophy at Wembley Stadium by Her Majesty The Queen as teammate Geoff Hurst (R) looks on. The stadium was packed to capacity, with 98,000 people crammed inside to watch the game. England was the first host nation to win the World Cup since Italy in 1934.

30th July, 1966

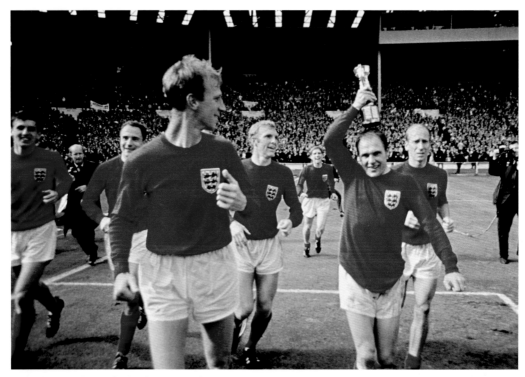

England's Martin Peters, George Cohen, Jack Charlton, Bobby Moore, Ray Wilson and Bobby Charlton parade the Jules Rimet trophy around Wembley following their 4–2 World Cup victory over West Germany in 1966.
30th July, 1966

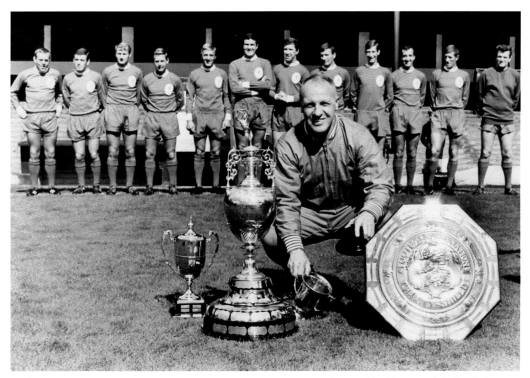

Liverpool manager Bill Shankly crouches by the trophies that his team won during the 1965–66 season, including the League Championship trophy and the FA Charity Shield. His players line up in the background: (L–R) Ian St John, Ian Callaghan, Roger Hunt, Gordon Milne, Peter Thompson, Ron Yeats, Chris Lawler, Tommy Smith, Geoff Strong, Gerry Byrne, Willie Stevenson, Tommy Lawrence.

15th August, 1966

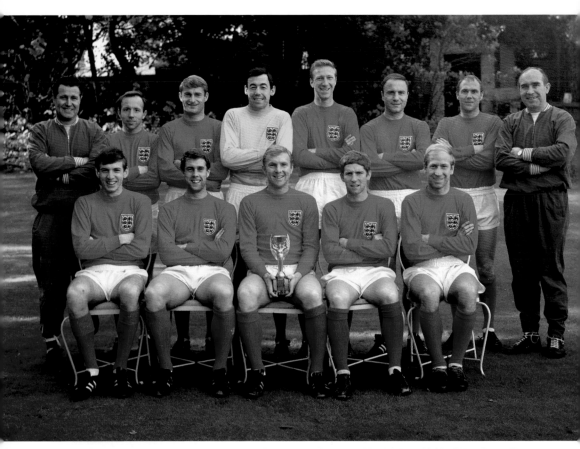

The 1966 World Cup-winning England team group: (back row, L–R) Harold Shepherdson, Nobby Stiles, Roger Hunt, Gordon Banks, Jack Charlton, George Cohen, Ray Wilson, manager Sir Alf Ramsey; (front row, L–R) Martin Peters, Geoff Hurst, Bobby Moore (holidng the Jules Rimet trophy), Alan Ball, Bobby Charlton.
2nd November, 1966

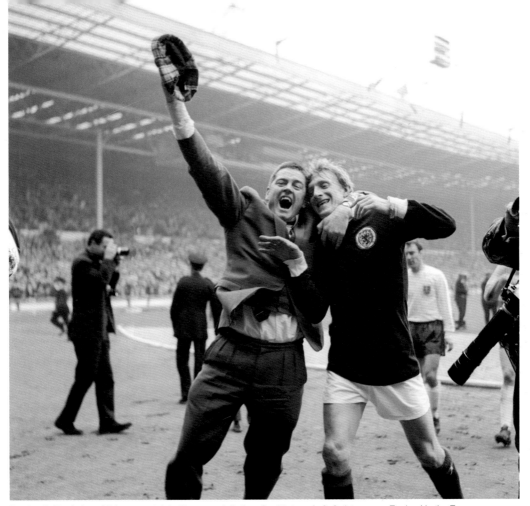

Scotland's Denis Law (R) is congratulated by an ecstatic fan after his team's 3–2 victory over England in the European Championship qualifier in 1967.

15th April, 1967

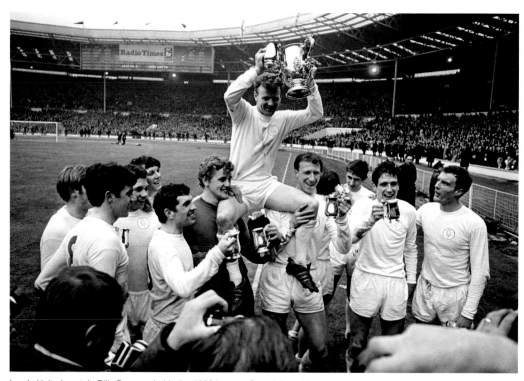

Leeds United captain Billy Bremner holds the 1968 League Cup aloft as his teammates carry him on their shoulders. Leeds won the League in a 1–0 clincher against Arsenal.
2nd March, 1968

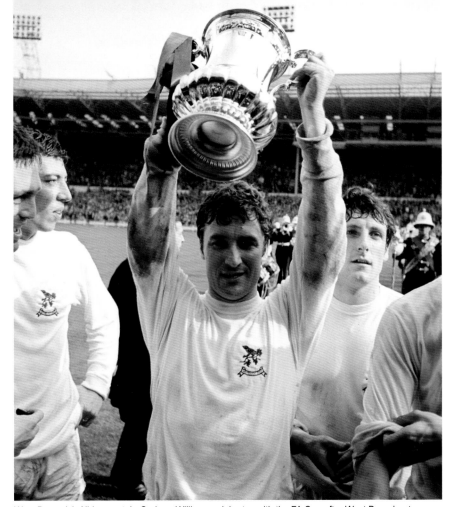

West Bromwich Albion captain Graham Williams celebrates with the FA Cup after West Brom beat Everton 1–0 in the 1968 Final.

18th May, 1968

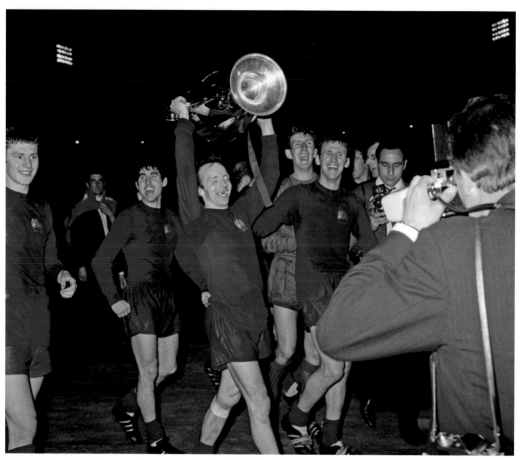

Nobby Stiles with the European Cup after Manchester United beat Benfica 4–1 in the 1968 Final. L–R: Brian Kidd, Tony Dunn, Nobby Stiles, Alex Stepney and Pat Crerand.

29th May, 1968

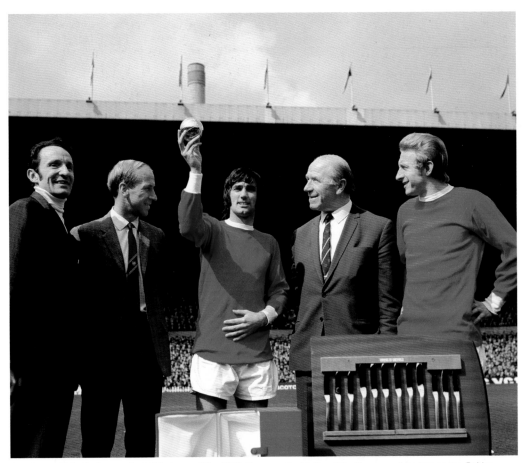

Manchester United's George Best (C) shows off the 1968 European Footballer of the Year award, as teammates Bobby Charlton (second L, 1966 winner) and Denis Law (R, 1964 winner), and manager Matt Busby (second R) look on.
19th April, 1969

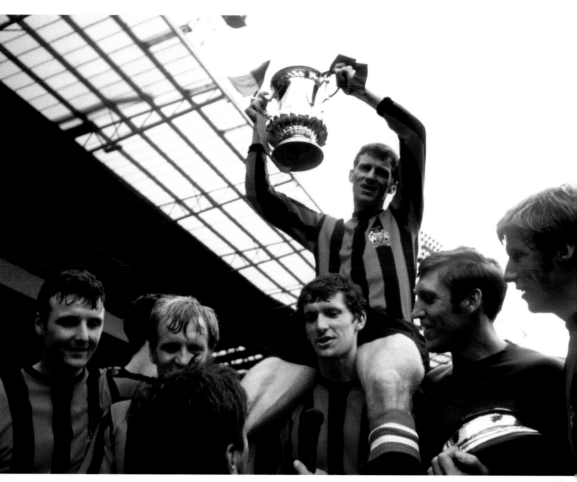

Manchester City Captain Tony Book is carried on Mike Doyle's shoulders as (L–R) Glyn Pardoe, Francis Lee, Harry Dowd and Colin Bell celebrate winning the FA Cup in 1969. The squad clinched the victory by beating Leicester City 2–1.
26th April, 1969

Everton's Alan Ball marches back to the home dressing room with the Football League Championship trophy under his arm after his team's 2–0 win over West Bromwich Albion wrapped up the title.
1st April, 1970

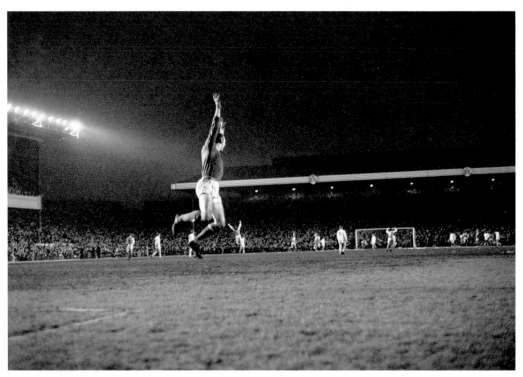

Arsenal goalkeeper Bob Wilson leaps for joy as the Gunners' third goal enters the Anderlecht net to give the Londoners a 4–3 aggregate victory in the European Fairs Cup Final at Highbury in 1970.
28th April, 1970

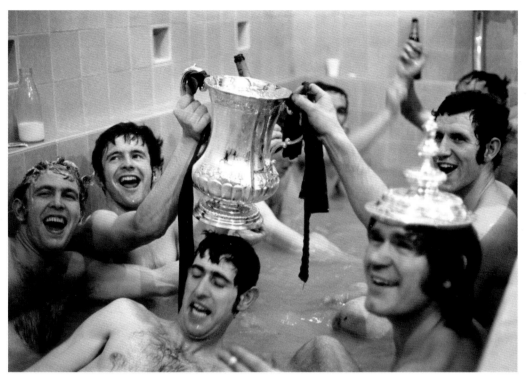

Chelsea's John Hollins (second L) and Peter Osgood (R) celebrate their 1970 FA Cup victory with the trophy in the plunge bath, alongside teammates Tommy Baldwin (L), Peter Bonetti (C) and David Webb (second R).

29th April, 1970

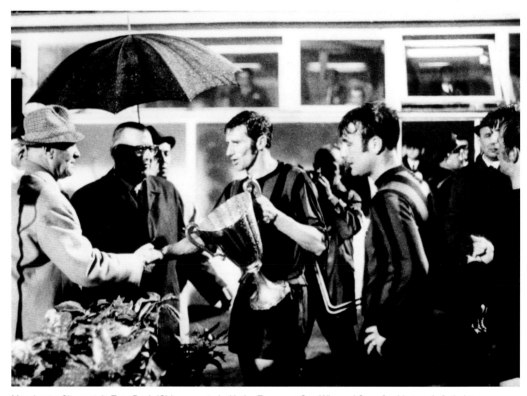

Manchester City captain Tony Book (C) is presented with the European Cup Winners' Cup after his team's 2–1 victory over Gornik Zabrze in 1970.

29th April, 1970

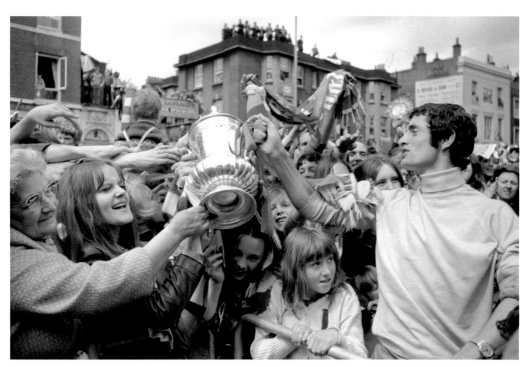

Arsenal captain Frank McLintock (R) lets fans in Upper Street, Islington, have a touch of the FA Cup during the team's celebratory tour of North London in 1971. The Gunners beat Liverpool 2–1 at Wembley in the Final.
9th May,1971

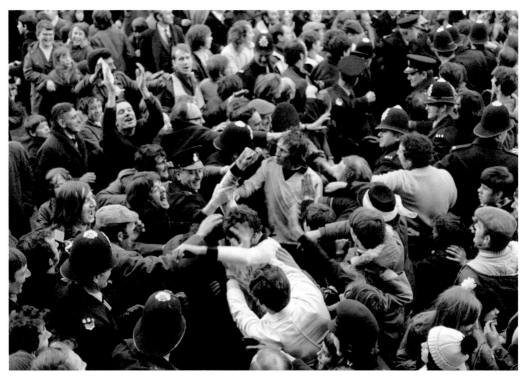

Hereford United players are mobbed by the jubilant home crowd after their 2–1 win over Newcastle United in the Third Round FA Cup replay. It was one of the greatest shocks in the history of the FA Cup. Hereford's win was the first time a non-league club had beaten a top-flight club in a competitive game since Yeovil Town's victory over Sunderland in 1949.

5th February, 1972

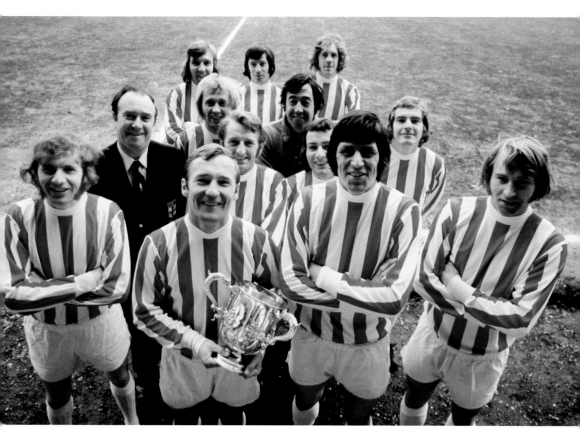

Stoke City with the League Cup in 1972. L-R: Mike Bernard, Alan Bloor, Mike Pejic, Jimmy Greenhoff, Gordon Banks, John Mahoney, Tony Waddington (Manager), George Eastham, John Marsh, Terry Conroy, Peter Dobing, John Ritchie, Dennis Smith. Stoke defeated Chelsea 2–1 at Wembley Stadium in the League Cup Final.
1st April, 1972

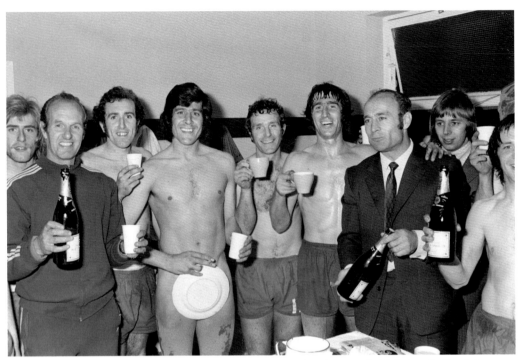

Norwich City celebrate winning the Second Division Championship in the dressing room: (L–R) Graham Paddon, trainer, Doug Livermore, Kevin Keelan, Terry Anderson, Duncan Forbes, Manager Ron Saunders, Trevor Howard.
29th April, 1972

Facing page: Leeds United's Allan Clarke celebrates his team's victory in the 1972 FA Cup with the top of the trophy, and his Charles Buchan's Football Monthly Man of the Match Award.
6th May, 1972

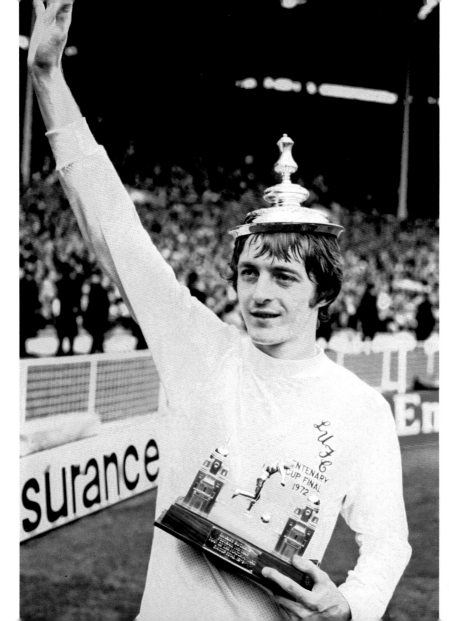

261

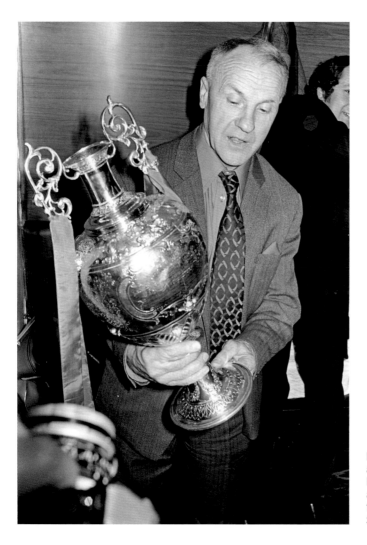

Liverpool manager Bill Shankly takes an admiring look at the Football League Championship trophy in 1973 after the Reds win the League title following a draw against Leicester City.
27th April, 1973

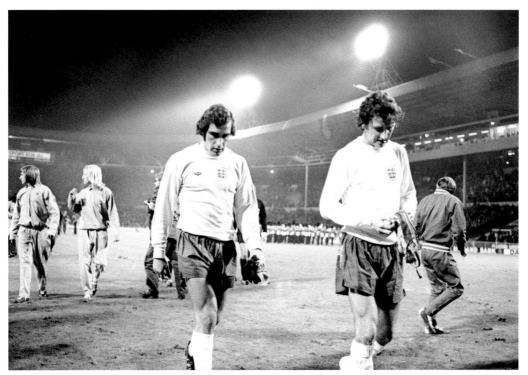

England's Peter Shilton (L) and Roy McFarland (R) trudge off the field after the team's failure to qualify for the 1974 World Cup finals in West Germany. The match against Poland resulted in a 1–1 draw, with England needing a win to qualify.
17th October, 1973

Aston Villa goalkeeper John Burridge (L) and hat-trick hero Brian Little celebrate reaching Wembley after their team's 3–0 victory over QPR in the Football League Cup Semi-Final Replay in 1977.

22nd February, 1977

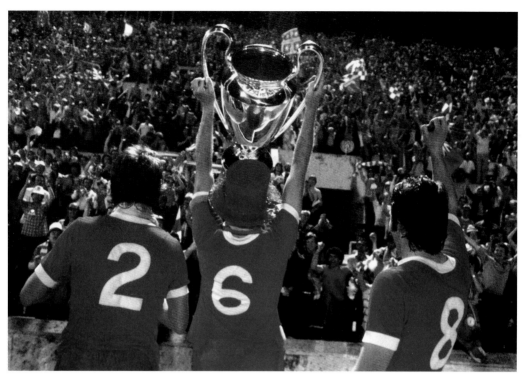

L–R: Liverpool's Phil Neal, Emlyn Hughes and Jimmy Case show the European Cup to their jubilant fans in 1977.
The Reds took on Borussia Mönchengladbach of Germany at the Stadio Olimpico in Rome, Italy, clinching a 3–1 win.
25th May, 1977

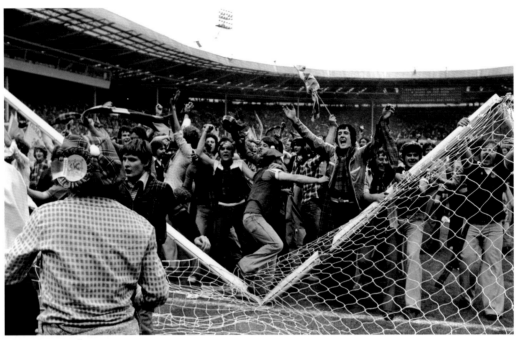

Jubilant Scotland fans demolish the Wembley goalposts after seeing their team win 2–1 against England in the 1977 Home International Championship.

4th June, 1977

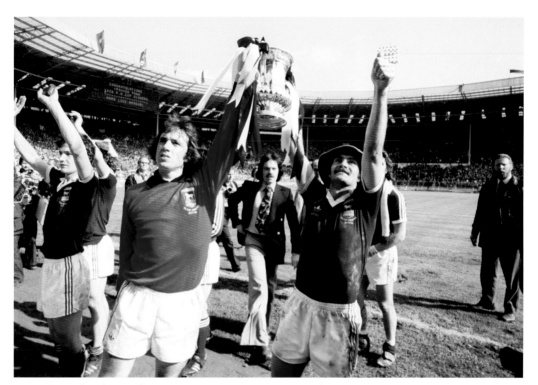

Ipswich Town's Paul Cooper (C) and Mick Mills (R) celebrate with the FA Cup, as teammate George Burley (L) waves to the fans. Ipswich's 1978 triumph was the result of the team vanquishing Arsenal in a 1–0 win.

6th May, 1978

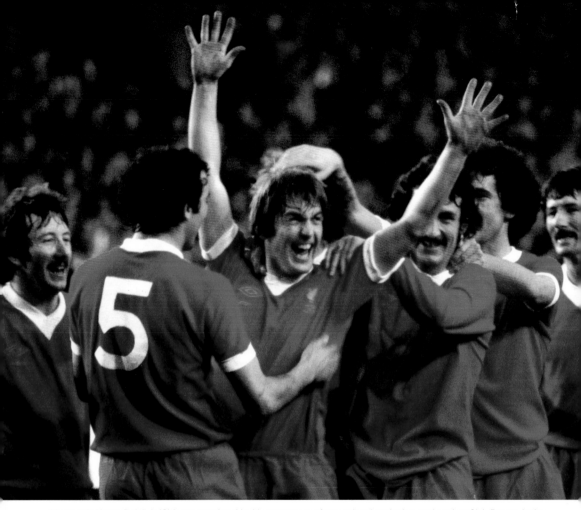

Liverpool's Kenny Dalglish (C) is congratulated by his teammates after scoring the winning goal against Club Brugge in the 1978 European Cup Final.

10th May, 1978

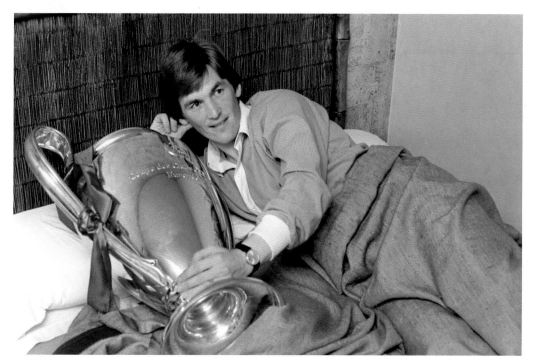

Liverpool's striker Kenny Dalglish wakes up with the European Cup after scoring the winning goal in the previous night's final. The Reds defeated Club Brugge of Belgium in a 1–0 victory.

11th May, 1978

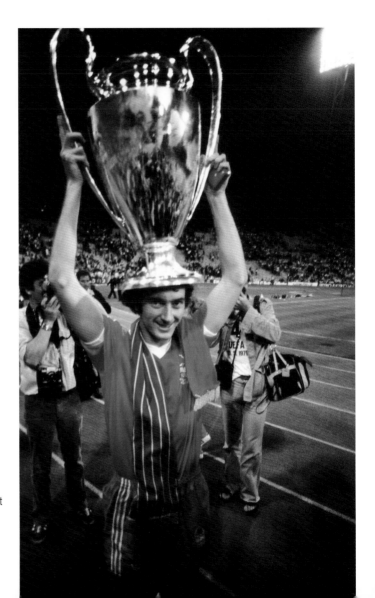

Nottingham Forest's winning goal-scorer Trevor Francis celebrates with the European Cup in 1979. Forest defeated Malmö FF of Sweden 1–0.
30th May, 1979

Nottingham Forest's Larry Lloyd celebrates after Forest follow up their 1979 European Cup victory by winning the trophy for a second time in 1980. Forest were the victors in a clash against German team Hamburg, beatiing them 1–0.
28th May, 1980

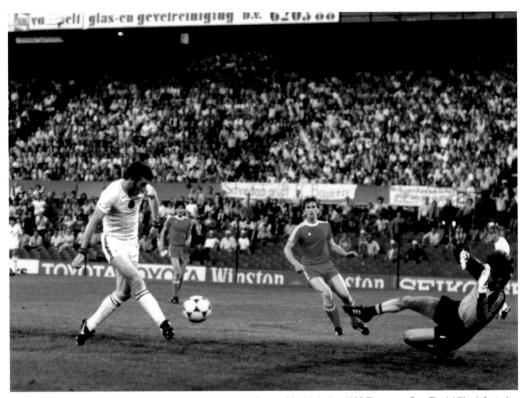

Aston Villa's Peter Withe (L) scores the winning goal against Bayern Munich in the 1982 European Cup Final. Villa defeated the West German team 1–0 at De Kuip in Rotterdam, Netherlands.

26th May, 1982

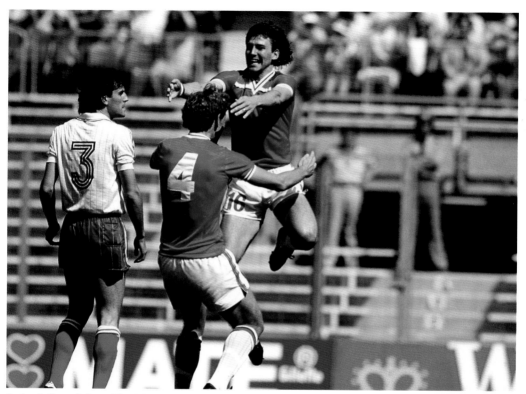

England's Bryan Robson (R) celebrates with teammate Terry Butcher (C) after scoring the fastest goal in World Cup history – just 27 seconds after kick-off. The 1982 match was a 3–1 victory for England against France.
16th June, 1982

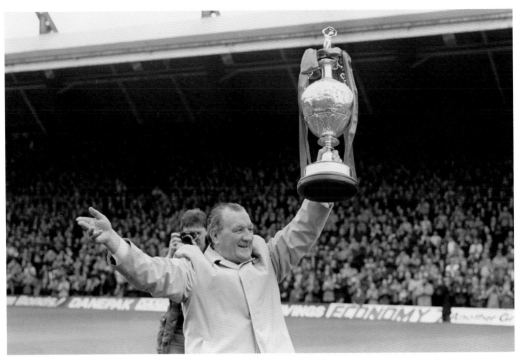

Liverpool manager Bob Paisley shows off the League Championship trophy to the fans at Anfield after the Reds' victory in 1983. They secured victory by drawing with Aston Villa 1–1, giving them enough points to win the League.
7th May, 1983

Aberdeen's John Hewitt scores the winning goal of the European Cup Winners' Cup Final in extra time against Real Madrid.
11th May, 1983

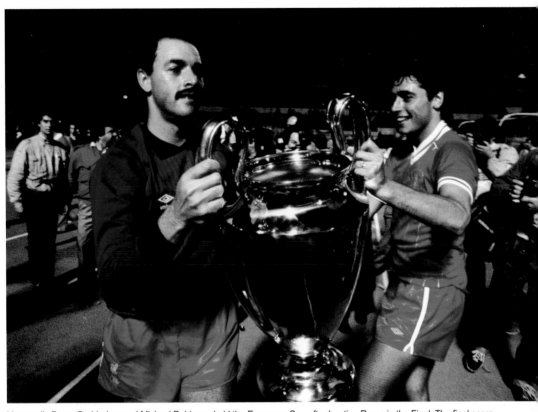

Liverpool's Bruce Grobbelaar and Michael Robinson hold the European Cup after beating Roma in the Final. The final score was 1–1, with the outcome being resolved in a penalty shoot-out.

30th May, 1984

Argentina's Diego Maradona (R) flies past England goalkeeper Peter Shilton after using his fist to score the infamous 'Hand of God' goal, in the 1986 World Cup Quarter-Final match. Argentina defeated England 2–1, and went on to win the Cup, beating West Germany 3–2 in the Final at Mexico City's Estadio Azteca.
22nd June, 1986

England coach Don Howe (L) and physiotherapist Norman Medhurst (R) console manager Bobby Robson as Chris Waddle misses a vital penalty in the shoot-out against West Germany in the World Cup Semi -Final. England lost in the shoot-out, ending the dream of a place in the World Cup Final.

4th July, 1990

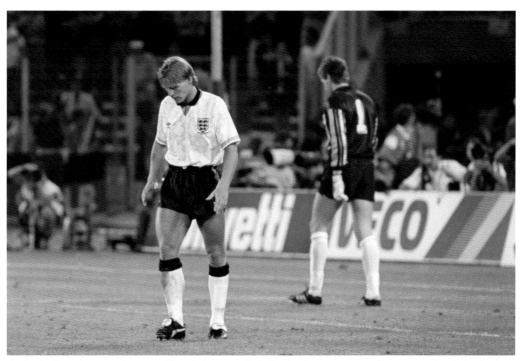

England's Stuart Pearce walks away after missing a penalty in the shoot-out against West Germany in the 1990 World Cup Semi-Final. The match ended in a 1–1 draw, forcing a sudden-death shoot-out to decide the outcome. Devastated by his failure, Pearce left the field in tears.

4th July, 1990

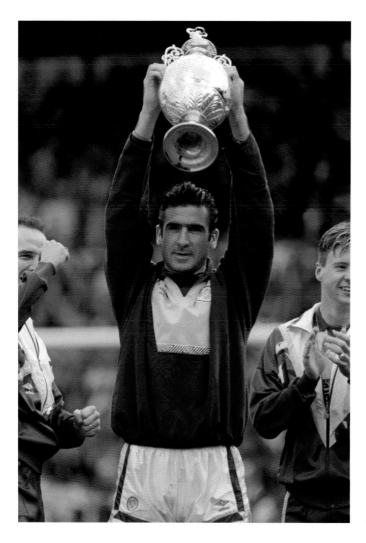

Leeds United's forward Eric Cantona lifts the League Championship trophy. The Yorkshire club defeated rivals Manchester United by four points (82 to 78) on the League table to clinch the victory.

2nd May, 1992

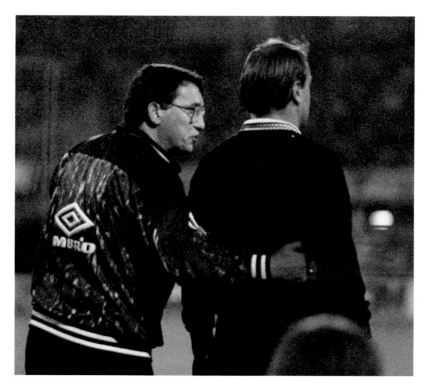

England manager Graham Taylor mutters the immortal words *"Your mate's just cost me my job"* to the linesman during the World Cup Qualifier against Holland in 1993. The Dutch side defeated England 2–0.

13th October, 1993

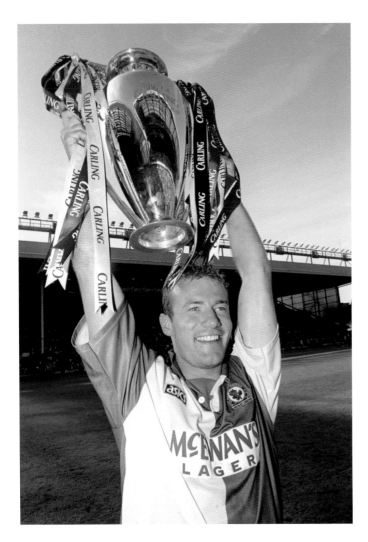

Blackburn Rovers' striker Alan Shearer celebrates by holding aloft the Carling Premiership trophy in 1995. Despite Liverpool defeating Rovers 2–1 in their final game of the season, Blackburn won the League on points, edging out rivals Manchester United.

14th May, 1995

Eric Cantona of Manchester United (L) celebrates with teammate Roy Keane after scoring from the penalty spot against Liverpool on his return to soccer after a nine-month suspension in 1995. The game ended in a 2–2 draw.
1st October,1995

England goalkeeper David Seaman celebrates after saving a penalty from Spain's Miguel Angel Nadal, which put England through to the Semi-Finals of Euro 96.

22nd June, 1996

England's Stuart Pearce exorcises the ghosts of penalties past as he celebrates after scoring in the penalty shoot-out to decide the Euro 96 Quarter-Final clash against Spain, at Wembley.

22nd June, 1996

England's David Beckham (R) is shown the red card by referee Kim Milton Nielsen in the World Cup Second Round match against Argentina in 1998.
30th June, 1998

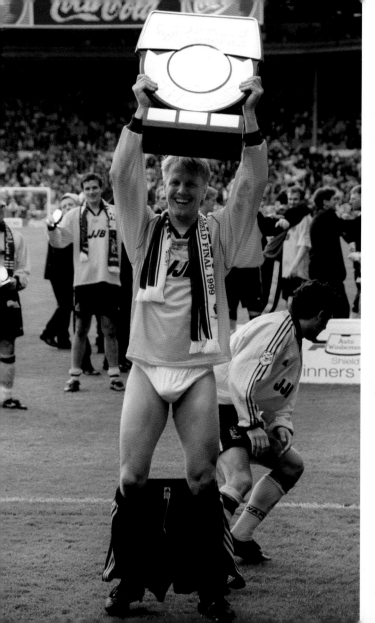

Wigan Athletic's winning goalscorer Paul Rogers is the victim of a practical joke as he celebrates with the Auto Windscreens Shield in 1999.
It was a pants-down win for Wigan over their Millwall opponents.
18th April, 1999

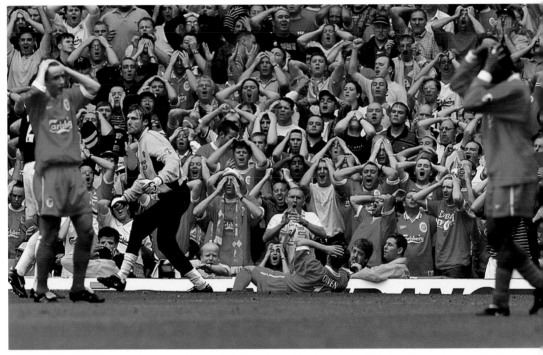

Michael Owen (on ground) and the Liverpool fans can't believe their luck as Manchester United goalkeeper Massimo Taibi (second L) keeps another shot out during an FA Premiership match at Anfield. Manchester United clinched a 3–2 victory.
11th September, 1999

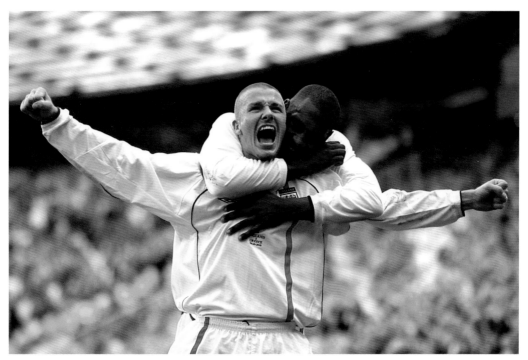

England captain David Beckham (front) celebrates with teammate Emile Heskey after scoring the equaliser from a free-kick against Greece in the dying seconds of the World Cup European Qualifying Group Nine match at Old Trafford in 2001.
6th October, 2001

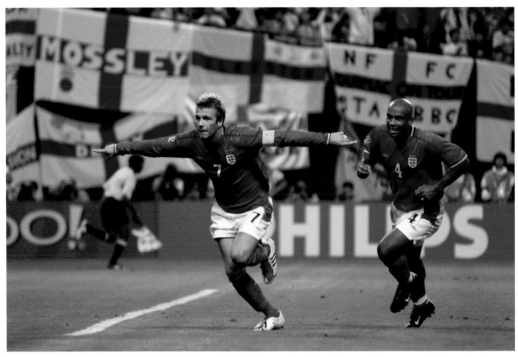

England's David Beckham (L) celebrates with Trevor Sinclair after scoring the winning goal from a penalty kick against Argentina in a World Cup Group F match in 2002.
7th June, 2002

Facing page: Liverpool captain Steven Gerrard takes a moment to reflect on his team's dramatic comeback against AC Milan in the 2005 UEFA Champions League Final. Three goals down at half-time, the Reds equalised in the second half and won 3–2 on penalties, retaining the trophy for Liverpool for another year.
25th May, 2005

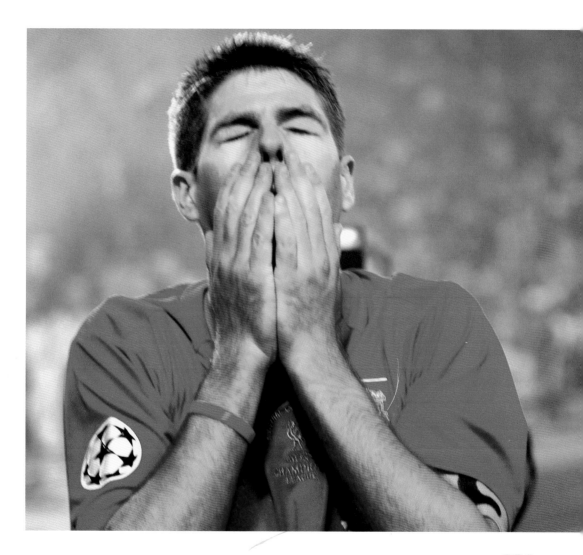

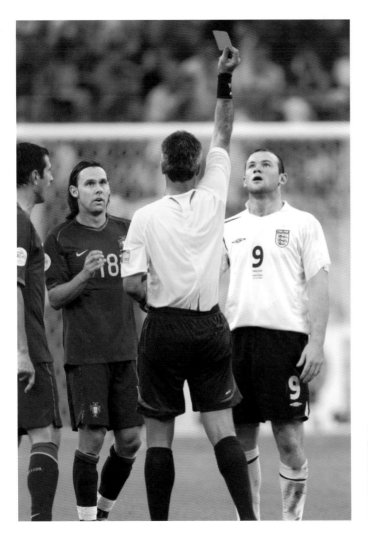

England's Wayne Rooney (R) is sent off during the 2006 World Cup Quarter-Final for a foul on Portugal's Alberto Ricardo Carvalho (L of referee). England were knocked out of the World Cup 3–1 on penalties after the match ended with a 0–0 score.
1st July, 2006

Celtic captain Neil Lennon holds the
Bank of Scotland Scottish Premier
League Trophy. His team took on
Heart of Midlothian at Celtic Park,
securing a 1–0 victory.
29th April, 2007

Moment of glory. Sunderland's Danny Collins (L) celebrates his goal with Nyron Nosworthy during the Barclays Premier League match against Aston Villa at the Stadium of Light, Sunderland. Villa would go on to win the match 2–1.
17th January, 2009

Wolverhampton Wanderers' Sylvan Ebanks-Blake (L) celebrates his third goal with Richard Steadman during the Coca-Cola Championship match against Norwich City at Molineux, Wolverhampton.

3rd February, 2009

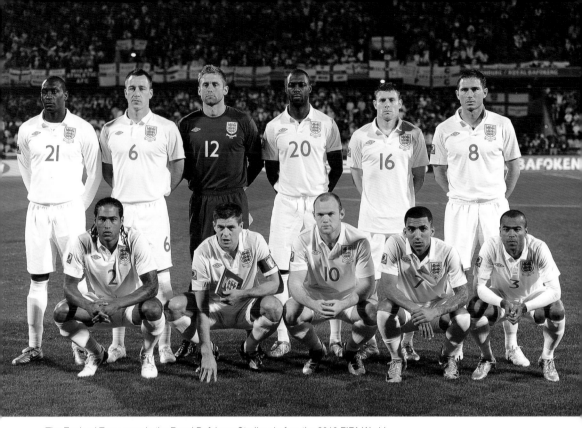

The England Team pose in the Royal Bafokeng Stadium before the 2010 FIFA World Cup South Africa Group C match against the USA. Front row, L–R: Glen Johnson; Steven Gerrard; Wayne Rooney; Aaron Lennon; Ashley Cole. Back row, L–R: Emile Heskey; John Terry; Robert Green; Ledley King; James Milner; Frank Lampard.
12th June, 2010

Football fans react to England's performance against the USA at the World Cup on a big screen at the Isle of Wight Music Festival.
12th June, 2010

Pause for reflection. Manchester United's left-midfielder Ryan Giggs in a contemplative moment. The welshman is the most decorated player in English football history, with a dozen Premier League winner's medals, four FA Cup winner's medals, three League Cup winner's medals and two Champions League winner's medals. In 2011 Giggs was named Manchester United's greatest ever player by a worldwide pole conducted by United's official magazine and website.

18th October, 2010

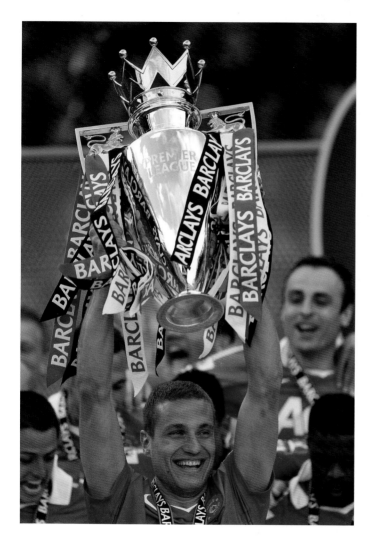

Manchester United's Nemanja Vidic hoists the Barclays Premier League trophy aloft after his team's 4–2 win over Blackpool.
22nd May, 2011

The Publishers gratefully acknowledge Press Association Images, from whose extensive archive the photographs in this book have been selected. Personal copies of the photographs in this book, and many others, may be ordered online at www.prints.paphotos.com

AMMONITE PRESS

PRESS ASSOCIATION Images